Pieces of a Boy

A FEW *QUEER* THINGS THAT HAPPENED

PIECES OF A BOY.
A FEW QUEER THINGS THAT HAPPENED

Author: Sam Morris
2024

Front cover artwork by Jonathan Kent Adams
Layout & design by Sexydesign Studio
Edit & foreword by Otamere Guobadia

Published by Sam Morris
Sam Morris ©
www.sammorris.me

Second Edition printed May 2024

ISBN 978-1-3999-7679-4

For Danielle,
my best friend.

Foreword
by Otamere Guobadia

If the age-old maxim is to be believed—that love makes the world go round—then shame is the swirling pitch that halts its revolutions, cloaks the brightness of our lives in shadow, sty, and suspicion, drowning us before we might correct course in search of kinder isles.

Pieces of A Boy is a serious and determined ritual of confrontation, in which Morris meets shame—pains and perpetrators, past and present—with unflinching courage, unsaddles himself of a lifetime of unmet expectations, and ultimately drinks it down like a tonic. In a series of vignettes, set out in 'Acts' and 'Interludes' (a nod to Morris' early life as a child star of London's West End) each more revealing and raw than the one before it, Morris lays bare the foundations of his inner world charting the life and times of a boy-cum-man, an artist at odds with the world around him—a classist, heteronormative society, that grinds even the conforming into boxes, and the unwilling into dust.

Through the lens of adulthood, and with a deeply unaffected bluntness that gives way to revelations and turn of phrase both profound and comic in turn, Morris exhumes difficult personal histories, reappraising the violences visited upon him and those around him—by those around him. He navigates difficult emotional terrain to paint a vivid, textured

portrait—foregrounding the light and the dark. We follow Morris' life through the slings and arrows of outrageous fortune: the estrangement of family, terrifying, battle-royale years in an elite and frightfully competitive school for the performing arts, through Berlin hedonism, adventures in love and lovelessness.

There is no straightforward arc of harm and forgiveness, no cookie-cutter feel-good story of redemption and restoration—happy endings may not be so easily won in Morris' world. In his distinct voice, he guides us through these defining and formative episodes, and, with artistic perseverance, succeeds in carving a life for himself out of the rocky hand dealt by fate. Devoid of the therapy-speak that permeates much of our time and discourse, Morris has created a kind of unvarnished, non-linear bildungsroman. *Pieces of A Boy* is a story of self-discovery, of damage and repair.

Frank yet deeply sensual, Morris deftly unpacks erotic encounters, kink, sexual adventure and misadventure, offering us ring-side views of a gay man in search of embodiment, well-being and true, unfettered sexual liberation. His story is a roadmap for reckoning with the way we are and what makes us the way we are, and how we might move forward without distorting or repressing our account.

Through these interconnected and beautifully written movements, Morris exculpates himself and others who stand in the margins of our fiercely stratified society; he confirms an indelible moral truth—the pariah is made, never by their own deficiency, but by the deficiency and fear of a societal order unprepared to deal with their differences—shining and otherwise.

PROLOGUE

Closure

There is the distant thump of techno music: incessant vibrating through my bones and into my core. Every pounding beat, reminiscent of my own thoughts I can't shut out. It's the third day of Whole festival in Ferropolis —an abandoned German mining site in Leipzig— and I am yearning for quiet. I booked the full four days with a comic amnesia and a total lack of self awareness. Not sure what I was thinking, but I'm definitely not someone who can make it through a full four days of tent-sleeping at a festival. I book a last-minute bus back to the city, along with a hotel, to escape on day three. At this point, the idea of a clean bed and a shower is more thrilling than any drug. It was predicted to rain all weekend, and much to my delight, the first day ended up being totally dry. I had envisioned myself putting up a tent like Tom Hanks in Cast Away, so I was very grateful to see the clouds clear away. On Saturday, however, it poured torrentially for about eight hours straight. I was dying to sleep— having not done so the night before—so the rain came as somewhat of a godsend. It was a real-life 'Alexa play sleep sounds.' The sound of it hammering down on the tent managed to drown out all the other festival din and the constant throb of distant bass. I actually fell into a deep sleep. It was blissful, and I dreamt I was lying by a swimming pool, my fingers caressing the water beside me. I glided my fingertips through the water, back and forth, in a deep state of relaxation. I quickly came to

the conscious realisation that my thin blow-up mattress was in fact laying in a 5-inch pool of rainwater.

Serenity quickly vacated the tent. I jerked upright in panic. Alas, it turns out my tent was not in fact waterproof— as the box so confidently described. Luckily my friend, who had lent me most of my camping things, had persuaded me to take a little camping chair. 'Trust me,' she said, 'Everyone will be envious of your little chair.' Being honest, I was sceptical of the chair at first, deeming it an unnecessary burden to carry. However, when I rolled over in my sopping wet dream of a sleeping bag, and saw my worldly possessions safe and dry atop the little camping chair of everyone's envy, I breathed a sigh of relief. My tent was on a slight incline, so while surveying the damage I realised that most of the water had pooled at one end: the end I'd been sleeping in. Good for most of my stuff, terrible for my bed. Whilst salvaging my things amidst this wet hell, I managed to distract myself, momentarily, from my absolutely horrendous hang-xiety.

When I arrived on the first night I went all out, as did many. It was the first Whole festival since before the pandemic; the sun was shining down despite rainy forecasts, and the energy exuding from fellow revellers was just electric. It was impossible not to get swept away in the atmosphere. I drank a lot, then did a fair mix of coke and mephedrone throughout the night. The coke sort of just kept me going—kept me awake— but the mephedrone really made me lose my head. Despite my better intentions, I ended up in the cruising area for about 6 hours. It was basically 6 full hours of me yanking at my sad, limp coke dick, which at this point had less blood in it than a luxury black pudding. I had sworn to myself I'd be on my best behaviour and would stay

away from darkrooms and cruising areas because of the monkeypox outbreak. 'Let's just have a look,' were the famous last words I'd said to my friend's boyfriend. He'd been my buddy for the weekend, his boyfriend having already ditched us hours ago for said darkroom. Just fags doing fag things. We peeked inside, and within a few moments, the hedonistic matchbox of the surroundings ignited the mephedrone inside us: our mouths met like the opposite poles of two magnets and we didn't seem to unlock for the rest of the night. The cruising area,which was a dedicated zone for play, consisted of a dimly lit neon maze, some tented darkroom areas which were simply fences covered in a black bin bag-like material, and finally a shed in the middle, made to look like a grandma's cottage in the woods—complete with old furniture and portraits of grannies on the walls. We kissed and jerked, and sucked and licked, and explored, for literally hours. I got my limp dick sucked by some very optimistic men, my ass eaten by some realists, and my buddy was getting fucked at one point whilst one very high man was trying, tirelessly, to talk to me about nuclear physics.

When the sun started to rise, the fear set in. My friend and I stood next to each other for a little while, the glow of the morning sun exposing the bleakness of our backdrop, and our desperate but unfinished quest for satisfaction. We shared a look, and from our expressions, it was clear we agreed it was probably best to call it a night. We decided to go back to our tents at about 8 am. I'd had a lot of fun, but upon morning, blue balls and regret were pretty much all I was left with. For the next 5-21 days I knew I'd be panicking and waiting to see if there was a biblical pox upon me. I pray I will be fine. 'We can't just stop living,' I unconvincingly reassure myself. I slept for most of Saturday through the rain storm. The next night I wasn't really in the mood to go all out: my bed

was soaked, and I was hanging in rags from the night before. So after a few drinks, a few lines, and a bit of dancing, I decided to call it a night and head back to the tent to sleep. The following morning, I decided to throw in the towel completely. I was absolutely done: I needed quiet and a real bed. I started packing my shit together, grabbing my bottle to fill it up at the water station.

People walk past with rolled-up tents and backpacks upon their shoulders. Grey faces, hair skewed in the memory of a shape from the day before. Some people are still going— sunglasses on, jaws swinging, pounding their way through the space like they're desperately late for something. On the way to the water pump, I bump into some friends who ask if I'm leaving already and if I have time to go for one last dance. My bus wasn't for an hour, and to be honest, my friends had already left so I'd just been meandering about trying to kill time before it. 'I can go for a walk with you for a little bit, then I'll head back,' I say. We wandered around the festival grounds, past a couple of stages, and around to the beach stage. I explained that I'd had a lot of fun, but was tired and needed to go ground myself back in the city. Festivals are an oasis, a mirage to quench a thirst. There is no sense of time— all boundaries seem to evaporate—but your body is left feeling fragile by the pilgrimage, and your mind, spacey. I was totally sober this afternoon, and that left me a little overwhelmed as we entered the beach stage area. It's an impressive space: a huge music stage, sat down in the shallows of the water. A DJ booth upon it, sitting inside a larger-than-life open-mouthed puppet, and a huge crowd of intoxicated people on the beach facing it, dancing. 'Let's walk over here,' my friend suggests, and so I follow. He stops to say hi to someone and I turn to look around the space. I recognise a body walking through the crowd

towards us. I knew his gait, the way he walked with his feet turned slightly out and his weight resting back on his heels. He is topless, and I recognise the shoulders, the neck, and the slight flush of hair sitting in the middle of his chest. I recognise the side profile, the familiar nose and chin, his short brown hair, and the gap between his two front teeth, as he turns his face in my direction to smile at a friend. A feeling of warmth runs through me. It's my ex from Copenhagen. My arm, without my permission, reaches out to grab his shoulder— a reflex of sorts. He turns to me, and I smile. 'Sam!' he grins Italian accent still as strong as ever. 'Sam' always pronounced 'Sam-uh' with a lilt at the end.

'You're here!' he says, wrapping his arms around me. 'I am,' I respond simply. He holds one hand around my waist, and with the other rubs my shoulder. He introduces me to his friend standing opposite us. 'This is Sam, we dated one time,' he says, giggling a little. He turns his attention back to me, asking how I am, and if I've enjoyed the festival. I say yes, but explain that I was leaving. 'Ah ok.' He looks disappointed and holds onto me tighter.

His hand caresses my waist, and I feel a weakness spread up from my ankles to my knees and the warmth grow within me. 'You look great. Your body, it's bigger. You've been working on it I guess,' I bashfully suggest. And he did look great: tanned and athletic.

'Thank you,' he replied, suddenly letting go of me. 'I want to go home tonight too,' he said, turning to his friend. 'I'm not sleeping another fucking night in a tent, no way, I'm not doing it. No fucking way!' He plays the primadonna: 'I want to go home tonight, so we need to figure it out!' he demands to his friend. I remember him having quite a volatile temperament at times, but I'd forgotten this particular

energy. I never found it particularly redeemable, but now without love obscuring my vision, it was especially less so. I needed to go, but something was keeping me rooted in that sand next to him. Old scars had reopened, and those wounds were holding me captive. I looked for my other friends but they were already long melted into the crowd. 'I should go,' I say, my hand up and down his waist affectionately, but in an 'I'm leaving now' gesture. 'Ok. It was nice to see you,' he says, before leaning in and kissing me on the lips. It catches me off guard. For a moment, I think how bizarre it is that one can be so close to another— entangled both physically and mentally—then become so estranged. It felt like someone I didn't know was kissing me on the lips. It felt inappropriate, yet at the same time totally appropriate. I put my hand on the back of his neck, and rub his hair a little. 'Nice to see you babe,' I say. 'And you,' he reciprocates. My hands leave his skin, peeling away like Velcro. I walk away and suddenly I am filled with existential angst. I had spent this entire weekend without even knowing he was here, then only just upon my departure, our paths crossed. I'm not a particularly spiritual person, or somebody that really believes in anything other than basic coincidence; I am a cynic at heart. However, in my fragile post-substance stupor, even I couldn't help but feel like this was a message from whatever powers might be. If there is a divine being of some sort, or the universe is playing puppeteer with our fate, then I was definitely given my time here free from him— until the very last moment. A messenger from the cosmos sending me a note upon departure from this utopia; a reminder of where I've been, and how far I've come; a full circle moment. Back in Berlin, back at this festival, and back in his arms for a split second, all these years later. I had felt unmoored, and his familiar touch on my skin had reminded me of the love I once had in my life. He reminded me of a warmth I once felt, that

I struggle to identify now. My love for him was complex, and mostly unrequited, but for a moment just then I felt the flame that had once burned before.

A torch inside the dark cavern of my heart, where the lights have felt for some time, extinguished. I walked back to my tent. I rolled it up and I picked up all my camping bits and my bag. I felt so weak: I'd hardly slept all weekend, and had eaten only bananas. I brought enough bananas with me to the festival to feed a generation of gorillas, and they ended up being breakfast, lunch and dinner for most of my stay. On my way to the bus I kept having to take breaks; the bags were so heavy on the long walk across the grounds I legitimately thought I was going to collapse. I donated my tent to a charity booth. I was sure they'd make better use of it than I. I walked to the bus, put my things in the hold, and found my seat. The comfort that rushed over me upon settling into that luxurious seat, was one that I had forgotten existed. I had full-body tingles. I was exhausted, so I rested my head back and allowed my eyes to close, whilst the bus gently rocked me to sleep, and bore me back to the city.

When I arrived back to my hotel, the feel of carpet under my feet— along with the smell of fresh linen—was orgasmic. I hadn't showered all weekend, other than a fresh water spritz up my ass with a portable douche I carry everywhere with me and a wet wipe over the end of my dick. A poor man's whore's bath. I smelled of stale sweat and ass, and there was mud on my calves and dirt under all my fingernails. I took my clothes off and practically leapt into the hotel shower. It is no exaggeration to say that the feeling of that hot water and soap was more euphoric than most drugs I've tried. Seriously, I could've cum. I scrubbed

myself all over, and after I was clean and dried off I slid into bed, passing out as the fresh cotton slipped over my clean skin. The next day I woke up well-rested, having slept for about 14 hours, to a text from my ex. 'I think I'm going to stay in town for a few days longer. Would you like to get dinner?' I was surprised to hear from him but found it pleasant nonetheless. 'Yes, that'd be nice,' I replied. 'Tonight?' He said. 'Why not?' I thought. 'Sure that works for me, where would you like?' I say. 'I don't mind, but nothing fancy.' He says. I suggest we go somewhere close to both of us, and he immediately suggests some-where else, much further from me. It was all too familiar, this game, of needing to travel far to see him, and him going as far as the end of his arms to meet me. I rolled my eyes to myself before typing back 'sure, I can meet you there.' For one night only, the world-renowned clown was back on the bill. He suggests 8.30pm and I agree to then. The evening rolled around, and I text him at 8pm to confirm he would be on time— I was absolutely starving by this point as I'd refrained from having an early dinner. He didn't respond until 8.25pm, by which point I was losing my patience. I'd expected we'd already have been sat eating at this point, and I hadn't even left my hotel yet. 'I'm leaving now so will be about 8.45,' he texts. 'Fine, see you soon.' I reply, grabbing my stuff and leaving. As I arrive at the station I see him from across the street and walk over. He walks straight past me, oblivious, with his head up looking everywhere but at me. I reach out and grab him. 'Oh hello! My friend is going to join us also for dinner. I was just looking for him. I hope you don't mind.' 'Oh…sure. That's fine,' I said, but I did mind. I mean I said I didn't, and in the grand scheme of things I didn't, but in that moment I absolutely did. Could we not have just had this dinner to talk by ourselves and catch up? It had been years since we connected, and it just felt, quite frankly, rude of him. His friend arrives, and we

exchange pleasantries. I was very polite and tried not to let on how I was truly feeling, but there was a noticeable frost between us— something didn't quite vibe and I wasn't quite sure exactly why that was. We chose a Vietnamese place to have food, and after sitting down it became quite apparent that I was the third wheel. They were both having a laugh about stories and friends back in Copenhagen and I just sort of sat there, fumbling through the menu uncomfortably, trying to give myself something to do. My ex starts telling his friend about some hot guy he'd had a thing for at the festival, and how he had been kissing him one minute, and then the same guy was kissing someone else shortly after. He was hurt by it, having thought this guy only had the hots for him. It felt weird to sit and listen to this, and I'm not entirely sure why. I wasn't jealous—I just felt odd, sitting in on a conversation that didn't feel appropriate for me, like I was eavesdropping. We hadn't yet reconnected in a way that made me feel like we could be as open as this. Then he started talking about how high he was on the weekend, specifically on GHB. GHB (colloquially known as 'G') is something I will avoid at all costs, not only because I'm scared of it, but because ethically it's a drug that comes with it's own particular baggage. A friend of mine died from a G overdose—as do too many gay men. With G, the line between euphoria, overdose, and ultimately death, is scarily faint. Like any drug, it can be delicious, but unlike any drug, this particular one involves a lot of discipline: knowing exact measures, setting timers to make sure you don't take too much between each dose, not mixing it with anything else, including and most importantly, alcohol. A G-hole or 'going under' when you see people slipping in and out of consciousness, has been somewhat normalised in the party scene. But it isn't a G-hole, it's an overdose. When you see people taking a nap at a party, or looking like they're unable to sit up straight etc, please check on

them. I understand that problematising drugs isn't helpful— it makes people do them more secretly, which can then make their use more dangerous and increase their fear of asking for help if they need it. However, I also don't think G use should be celebrated. Another pet Geeve of mine is that it often turns you into a sex pest. It makes you extremely horny and tactile, and there is something about this drug— unlike other 'sex drugs' like coke, 3mmC, and mephedrone for example—that loosens people's notions of consent. I have been sexually assaulted multiple times by men on G, had hard dicks thrust onto me, been grabbed, squeezed, groped. The word 'no' seems to mean less to someone on G. The drug blinds them, and anything and anyone seems to be fair game. I find being around people on G quite triggering and scary at times. It is for these reasons that my ex talking so casually about how he had taken G all weekend, proved a tough pill to swallow. This was a new thing, one he hadn't used to do in the time we had known each other. 'Oh my god, we actually…we had just dropped G moments before I saw you on the beach!' he laughed. My face probably froze. I flashed back to his arm reaching round my side and holding me, to his familiar touch bringing me a sense of peace in a manic moment. I get chills as he tells me this. His fingers and hands reaching out for me on that beach, his tactility, his warmth—it wasn't him, it was the G. It felt like a final irony, one final insult. In that moment, at the end of the festival, a hand reached out from him to meet me—to hold me, to re-mind me that at one point we shared a love—but even this was a false reading on my part. His affection in that moment suddenly felt like nothing but a drug fuelled illusion. I looked past him as he continued talking to his friend. I was finding clarity, finding a true sense of closure. You were never what I thought you were, only ever a projection of what I wanted. I wanted love and warmth, grounding and safety. You were

none of those things. You were self-serving and self-involved. I look at him opposite me chewing food with his mouth open: something I hated when we were together, but always ignored. I am suddenly revolted by him, and want to be anywhere but at that table with him and his friend. He demands something from the waitress, rude and uncouth; a bit of a brat. I wondered what the fuck I was doing here at this table, with what were essentially two strangers. We had nothing in common but the absence of love, the silence echoing in the space between us, across the table like a rock on a frozen pond. 'Are you still selling your book?' he says, breaking the reticence between us. 'What book? You wrote a book?' his friend asks. I pause, my eyes dart to my ex. 'You should lend him your copy,' I say, with a slight smile, quickly looking back down at my drink. 'You wrote a book? It's a novel? What's it about?' His friend continues to press, looking lost in the unspoken communication between us. I look back up at my ex. 'I did. Borrow his copy, I sent him one!' I sipped my wine. My ex remained quiet lifting his glass to his mouth to drink. His friend had no idea what was going on. I loved the thought of him borrowing the book, the penny dropping when it got to a certain character's description. 'It's a memoir of sorts. I'm sure you'll love it,' I said, finishing my wine and smiling at my ex. His friend still looked lost. 'Shall we get another drink elsewhere?' he suggested. I couldn't think of anything less satisfying — I just wanted to go back to my hotel. For once I think my ex and I were on the same page. 'Actually I'm gonna head back to my hotel, I'm knackered,' I say. We all paid and then meandered down to Kottbusser Tor. 'Okay. Well I'm getting on the U8, so I'll see you later I guess,' I said. 'I'm here for a few more days, so maybe we could see each other again before I go,' my ex responded. I'm not sure why he said that; I didn't believe he wanted to, and I had no desire to ever see him again. I hugged his friend briefly to

say goodbye, then I leant in to hug my ex. I knew this would be one of the last times I would ever hold this man. A fleeting goodbye, after years of getting lost in emotional mazes built by him— a 'mutual' love that I had constructed in my own head; a love written in disappearing ink. Oh how cliché to have pursued the unrequited so boldly. I grabbed the back of his neck, and with four words ended our endeavour. 'Bye babe. Enjoy Berlin.' I kissed his cheek, then I turned and left. I walked down into the subway, each fluorescent light reflecting off the coloured tiles, washing over me, and like each memory of him, disappearing behind me and down into the underpass. I felt tears rush up inside me— not because I was sad, but because I was free. I had hurt so much of myself trying to love him, and he was never for me. I feel more known by the streets of Berlin I've walked than I ever did by him. I have felt more love in the smiles of friends, in the clinking of glasses, and in bottle tops popping off in the Spaiti shops. I perhaps still have a unique love—or something like it—for him, dusty like an antique left on a shelf, and a compassion for myself for having loved him. As much as I feel that he never really knew me, I equally never saw him for who he truly was, he was just a boy who's smile held me prisoner in the most instinctive sense. After all that's since come along in my life, and all the sense I've made of things, I know that I loved him. The most honest, rawest thing one can do, is to love without question or hesitation— like a teenager, like a child. To love without fear is true freedom. I wish I could have just a piece of that vulnerability back now. A vulnerability free of the pain I've been through in these last years. His face in my memory is a reminder to myself that I once loved without inhibition— freely and naively—and that was okay; more than okay. It was good. It was beautiful, youthful, and innocent.

ACT I

Theatre

I don't think there's been a time in my life where I haven't been performing. Performance has long been the blood running through my veins, has held my very being together since my earliest memories. Being a child actor, I spent most of my formative years on stage or in front of a camera. When you're a child, you're like a sponge, and there's something to be said about spending a lot of your time pretending to be someone else in a space that doesn't really exist. You spend so much of your actual life in a narrative that's been built and created for theatrical purposes. I'd rehearse for months, to perform in a show for a year, all the while pretending to be someone else, in an imagined time and reality. Then night after night I would be submerged in a world that didn't exist, during the formative years I was meant to be finding myself. I had a different accent, costumes, and the sound of a live orchestra painting the emotional landscape of my environment and feelings. I would spend every day in a different world, existing as another person. Alive, but not as myself. Then when a contract ended I would have to go back to my real life, slipping into a deep depression, even as a young child. I would cry and cry in my bedroom, dissatisfied with the concept of being stuck with my real life. I think when we see impressive child actors on stage or screen, many don't understand that often they're not simply being impressive actors, they're there. They embody that experience, they feel it and believe it is real. If anything,

they are the real method actors. I once worked on a TV drama for the BBC; I was third billing on the show so it was a pretty major role. At the time the part was potentially life changing, and almost opened some major doors for me, including being invited to audition for some huge movie roles, most notably Harry Potter—which I went through many rounds auditioning for the title role. The character I played on that BBC drama had asthma, and there was one scene in which I had to play out having an asthma attack. In the show I was rushed into hospital and had an oxygen mask put over my face. As a 12 year old I vividly remember finding this extremely frightening. I wasn't acting and there was actual oxygen coming out of the mask on my face. I remember being scared to breathe it in and between action and cut, I would try and hold my breath. Nothing about my performance changed between takes because I was legitimately scared. It was quite traumatic and I couldn't wait for it to be over. It is no coincidence that many child actors go off the rails as adults, because they have no clue who they are or what reality really is. I think the more demanding the roles that children play, perhaps the greater the trauma inflicted.

When you don't understand reality, nothing really ever feels tangible; the dissociation means we make questionable choices and our general outlook is bleak because it feels like nothing truly matters. It took me a while to realise that I had no idea who I was. I didn't really know where fantasy ended and reality began. Confronting the real world that stood in front of me me as I crossed the threshold into adulthood felt both threatening and violent. I went to a theatre school, one of the famous ones. I only ended up going because I was offered an 'assisted scholarship,' which basically meant that I didn't have to pay to attend— but any pay received from professional work up to the value

of a fully-paid place at the school, would be docked. I was missing so much school due to show rehearsals that it was concluded by the school and my agent that it was in my better interest to be part of the theatre school full time. I would never in a million years have gone to this school if it weren't for this scholarship. It was very expensive and was notoriously shit in the academic department. However, the year I joined a new academic headmaster had been recruited who managed to bring the GCSE pass grade percentage up from 13% to 99%, which was quite an impressive feat. I'd always wanted to be part of the school full time; I'd often worked with kids from the school in productions and been terribly jealous of their common morale, confidence, and overall fearlessness. It was like wearing that uniform gave you some sort of superpower. The kids were very precocious— that was the word thrown about at the time. It was a strange place, a bubble of hysteria and ego, further perpetuated by the adults in charge of the place. All teachers were on a first name basis. 'Your first steps as a professional,' they'd say. We were talking to teachers like employers from the age of about 10. They would swear at you and address you with such blunt vocabulary and you didn't really have a choice but to grow up pretty fucking quickly. And then a single word of praise was like giving a hyperactive child an entire bowl of jelly beans. Frightful. I definitely didn't have to worry about my ego being stroked too much. Once I was spontaneously asked to sing in a lesson, not out of the ordinary, as they liked to keep us on our toes. Midway through the teacher stopped playing the piano and grimaced. 'Eurgh! Sit down. That was vile,' he said. Ironically he was one of the nicer teachers. During one of my speech classes my teacher screamed that she could 'still hear Essex!' That's where I was from, but I was encouraged to erase that part of me pretty quickly after starting there. I sounded like a chimney sweep

around all those posh kids. They were desperate to scrub the working class off me the moment I walked through the door. That same teacher locked a boy in a cupboard once because he hadn't learnt a monologue in time for an exam. Honestly, at times it was like something out of a Roald Dahl story.

Even the way our singing classes were organised was enough to make a teenage boy's hair stand on end. Broken Voices and Unbroken Voices. BV & UBV. I was about 15 when my voice finally broke, but until then at 11am on a Friday I would have to divert to my singing class, leave the boys my age to join boys as young as 9, swallowing my pride and begging my voice box to do something to rescue me from this hellish nightmare. I would stand amongst young children for years looking like Lurch from the Addams Family. It was humbling. When your balls finally stepped up to the plate and dropped you had to make the humiliating proclamation that puberty was finally upon you, and that you'd like to be accepted into BV. An official, in-person request had to be made. This particular teacher was beyond frightening, and IF he agreed that you could upgrade—as a singer, as a man— you'd walk into a class of rambunctious boys all cheering on your manhood and fist punching while yelling things like 'get in there my son!' and 'he's a man now!' As a generally embarrassed and ungainly teen I can assure you this was a new kind of fresh hell.

We were pushed and tested daily at this school. The school week was split into two, with three academic days and then two vocational days. The academic days were a comfortable relief from the demanding and nerve wracking vocational days, which consisted of all our performing arts classes. There was one academic day however—a wednesday— that I remember vividly. It was a music studies class we were working

on for our GCSE's. It was on the artistic side of academics, but quite full on schoolwork in comparison to our singing classes. Our music studies course was taken by the head of singing: in an academic sense he was less scary than he was as a singing teacher on Thursdays and Fridays. Except for this lesson, he came in and told us all to put our music folders away. This was a mixed genders class, as it was our academic school year, and not graded talent groups. He wrote the lyrics of One Voice by Barry Manilow on the blackboard in chalk. 'Right, today we're doing an audition for a school cabaret that's coming up,' he began. 'I'm gonna sing the chorus of this 3 times on the piano, then we're going to go around the room and hear everyone sing it one by one. So concentrate and learn it quick.' He then immediately began singing it. I hadn't actually heard some of the people in my academic year sing, having never been in the same vocational class as them—likewise they hadn't heard me sing either. I was suddenly terrified. Shivering with fear. In those situations you had no choice but to participate—quickly and professionally—or your school place would be potentially on the line. I remember shaking in my core singing that day, and even now I still know the lyrics to that chorus by heart; it feels like it sits in my DNA on a cellular level.

Every day of the week we had lists hung in the hallways, naming the entire school register, with columns for each year from 5 to 11. A talent agency, which had an office internally in the school, would highlight names throughout the day. If your name was one of the chosen, lit up in bright neon highlighter pen, you were to go to the agency and find out what audition you'd been selected for or what job you'd booked. This was in between classes. So on your way to each lesson for your entire school life, you'd be reminded daily by looking at that white, colourless

box, that you were not really worthy, needed, or employed. Then you were to continue to your next lesson, whilst others in your class got to leave for whatever exciting endeavour had come their way. You'd sit there, doing maths, subtly overthinking why it was that you weren't being offered any auditions, or employment. A totally normal thing for a 12 year old to contemplate daily. Unemployment. It was a head fuck, far cry from a normal schooling experience. I was a bit of a loner; I always found it hard to make friends, but particularly there. I found everybody too insincere. Disingenuous. Every morning was air kisses and big hugs; girls with Louis Vuitton bags slung over their elbows and rouged cheeks behaving like young women. Precocious.

I had one or two friends I chose to stay close to. When I first joined the school I found a boy I thought I liked. He seemed a bit odd, but we seemed to get on. I was usually more drawn to the oddballs: always have been, still am. We spent a bit of time together. Then one day between lessons I was walking behind him, off to the lunch room, when he turned around and said 'why are you following me?' That was the painful end of that friendship. I'd moved schools a lot before I ended up at theatre school. It's hard to keep hold of friends when you move around so much. I was a working class boy from Dagenham, lucky enough to get a scholarship to this school, and so it was pretty much a done deal that I would go. Being around so many rich kids was a culture shock: all designer school bags, iPods, and brand new Nikes. I had a pair of Storm trainers from Romford market. 'What's storm?' some of the kids would ask. I would come over in a cold sweat and go beetroot red. They'd purse their lips and smile in pity. There's a certain air of entitlement and pompousness amongst rich kids— add going to the country's most prestigious theatre school into that equation and that air becomes insufferable. I remember

my science teacher holding her head in pure exhaustion in one of our final year 11 lessons because the whole class decided to get up on the tables and sing Joyful Joyful from Sister Act 2—in a 4 part harmony no less— to celebrate the end of term. I stayed sat during this, filming everyone else on this little video recorder I had at the time, documenting the theatre in real time. I never got involved in group moments like that. I often felt like a fish in a goldfish bowl, looking through the glass at the madness in the room around me. I was there, but ultimately I wasn't. Excluded, maybe through choice, or maybe because I just simply didn't fit in. I always felt more understanding of the teacher's exasperation, but now I do even more so.

No communication or behaviour was ever ordinary. Even our principal loved to perform. One day she arrived in assembly with a huge box overflowing with paperwork. The door creaked open and the room full of students fell silent. She waddled to the front with this box, her back hunched over from the sheer weight of it. It felt like it took 10 minutes for her to get to the front of the room. When she eventually got there, BOOM. She dropped the box to the floor. Papers erupted out of the top, littering the surrounding floor. Everyone jumped out of their skin, particularly the kids in the front row who got hit with a gust of wind from the falling box. Plus, it was only 8.45am so it startled even the steely of us. 'THIS is a box full of applications to this school. Don't think any of you are safe here,' she proclaimed. Terrifying. Theatre. So life from a young age, even school, felt like I was on stage. That or a contestant in a fucking reality show. Which round am I in now? Was it my line? Will I be eliminated? It's no wonder the crippling anxiety I suffer with now as an adult, because my home life didn't give me much respite from the theatrics either.

Punch And Judy

My mother was very unpredictable growing up. It was pointless trying to predict what mood she would be in each morning, so caution was always the best option. My mum is very charismatic: a social butterfly, always very central to her friend groups, and whenever we were at a party or a function, my mother would be front and centre. She had arrived, and everyone would know about it. Long shiny brown hair, tall, huge tits. I would hide behind her legs, and mostly she would speak on my behalf. When I first started school, my mum would have to literally tear me off her legs and physically push me into the playground. I was a terrified child— scared of everything. I remember my mum teaching me how to cross the road. She would stand on the other side shouting 'Just come! There's no traffic now. Sam, come now!' I would just stand there shaking my head, looking side to side, as if I'd been asked to jump out of a plane. I was also very scared of people, of speaking to them, of basic communication. Looking back, there's a certain Stockholm syndrome to being the child of a narcissistic parent. For me, part of that was being spoken on behalf of. I became very accustomed to not speaking up for myself, and accepting the comfortable role of living in her shadow, well into young adulthood. There was a certain contradiction here though, as my mother decided to push me into show business. Now, I shouldn't say push— that was a very contentious topic when I was a child. 'We didn't push you! You wanted to do it!' she'd say. Apparently I was very

eager to go dance classes as a little boy, which I have no doubt about. That being said I went from seeing Oliver at the London Palladium at 7 years old for my birthday, to being in it at 9. I'm sure that a child as young as I was can have passions and interests, of course, but an active desire to work professionally in the West End without adult coercion, I'm not so sure. That was my first ever audition and I booked it. A lead role. I was tiny. A teeny-tiny, super shy 9-year-old. Front and centre at the London Palladium. It was quite miraculous really, because I was so genuinely extremely shy that I was scared to even speak to my own family at birthdays and holidays. However, when I disappeared into an acting role I didn't feel nervous, I just committed and did what was asked of me. It was like putting on a mask in many ways. On opening night my mum and dad sat next to each other, apparently shaking with nerves, and after I finished my solo, successfully, my dad apparently turned to my mum and said in jest 'It's only downhill from here.' Those words have haunted me ever since. It was such a huge opportunity for me—for us as a working class family—and from there I didn't really stop working as a child. I went from show to show. I think there was something about me being so quiet and shy that was endearing to producers. I wasn't difficult. I was just a quiet, but talented, little boy. I'm not sure how much I loved it; it was a whirlwind of a time and I don't actually have much memory of it. How does one really know what they loved doing as a child when one's experience can only be juxtaposed with what you're familiar with? I do remember getting terrible headaches from the microphones we'd have to wear around our heads in the shows: they strangulated my head and would leave me in horrid pain. I also recall being very tired. Long days of going to school, being picked up from the gate, driven into the West End, performing until 10 or 11 at night, and then driving home, getting into bed at midnight, then the next day starting again. It was a lot for a young

boy, but for me it was my normal, even though I knew it wasn't. I knew I was special, and in many ways I think I found enjoyment in that. I used to feel quite at home in the theatre, never nervous. There was something about being around people who celebrated you, and an audience that adored you, that I obviously used to love as a child. What child wouldn't? I escaped the unpredictability of my real life, and entered into a space of absolute predictability. Consistency. Every night was the same show, with the same characters, and the same audience reaction. It was a second home, that offered me love and routine. I think this was probably quite difficult for a 9 year old to fully understand but I get it now. My life in general, and particularly my relationship with my mum was like a seesaw. When we'd drive to the theatre we were like best friends. We would talk about everything, I was always full of questions and she would always answer; I saw her as an oracle. We'd sing Celine Dion together at full volume, and I could feel her visceral pride in me when I was working in a show. She would be buzzing and alive and me and everyone else could feel it. On her off days, she was very different. She would switch. It was like living with Jekyll & Hyde. If you so much as spilt a drink, the red mist would come over her and she would flip. I don't remember too much physical stuff, apart from being smacked (which wasn't unusual in the 90s), it was more so the yelling that has stayed with me. The red-faced screaming. The fear I would feel. Shaking. I would be desperate to hide from her at times. Petrified. From such a young age, it felt like I would yoyo between being a hero and a villain in her eyes: I was loved one minute, hated the next, and I was never sure where I stood. I knew that I made her happy when I performed, and so I did. But I lived in a constant dichotomy, being spoken on behalf of at any family event or at the school gates as I was too scared to communicate, then singing solo at the London Palladium every night.

I had night terrors for most of my childhood. I would get up in the middle of the night, too scared to open my eyes, too scared to stay in bed, but mostly too scared to wake my parents. Once I'd gained the courage to get out of bed, terrified of opening my eyes in fear of what I might see in the dark, I would silently creep to their bedroom across the hall on my tiptoes. I mastered the art of stealth nightwalking, able to move without making a sound. I would crawl under the blanket on the floor next to their bed. They were so used to me waking from my night terrors, and with them not wanting to be woken (or address why I was having them in the first place) they just put some blankets and pillows on the floor by their bed. A bit like for a dog, I guess. I was getting standing ovations and flowers at the stage door every night, then going home to sleep on the floor next to my parent's bed. I don't think my 9 year old brain really understood all of this. For the most part my parents called the shots and I just did what I was told. I never had a say. They said sing, I asked how loud. You might notice my dad isn't so present in this story, and that's because he simply wasn't so present. I seem to remember him being at work most of the time. I do remember my mum on her off days, amping up the terror by threatening 'wait 'til your dad gets home,' and my belief that I'd never again see the light of day. He would always back her up no matter what. I never had a 'safe parent' like some of my friends did. There was no good cop/bad cop, it was both full force for the most part. I was so scared and disturbed at times in my childhood that I would shit my pants— literally. I don't know how it started, but I was anally retentive. I just wouldn't go to the toilet. I would go to school and hold it in. Sometimes I would push my back against the wall, or sit on the floor and push my bum into the ground to push it back in. Usually this resulted in me shitting my pants. I used to have to find ways of getting rid of my underwear because when my mum occasionally found them

she would go absolutely ballistic. 'HOW THE FUCK DO YOU THINK YOU'LL EVER FIND A WIFE WITH SHITTY FUCKING PANTS?!' I was probably about 7 or 8 when she screamed this at me. Too young to understand what it meant, but I knew it wasn't good. I was never treated with compassion when these accidents happened, only scolded and told to never do it again. So when they would happen, I would usually take off my underwear in a bathroom in secret. I would attempt to wash the skid marks out with hand soap, then put them back on soaking wet and carry on with my day, hoping she would never find out. That or I would take them off and hide them. There was a staircase in my bedroom that led to the attic. I used to peel back a part of the carpet and hide my soiled underwear in there. I'm sure maybe she did notice while doing the laundry that my underwear was going missing, but I could deny that, or at least deal with that better than her finding out I'd shit my pants again. I became extremely calculated at a very young age in finding ways of keeping secrets from my parents. This went on until I was about 11, overlapping well into my time performing professionally on the West End. I was a boy celebrated—cheered on almost nightly with compliments and flowers—whilst dealing with deep deep shame at the fact I wasn't properly toilet trained. I can't quite imagine the coping mechanisms I must have created at such a young age to deal with that, but I can only imagine they were an extraordinary burden for such a young person. I do remember the feelings of sheer fear and shame; the panic and terror at the idea of being caught and coming up with ways to cover my tracks. I was in a constant state of performance, with everyone around me, including loved ones. This shame is not just something I would learn to become familiar with, but something I would learn to master. I was only in rehearsals for the real show.

INTERLUDE I

Freesia

Like me, my auntie Freesia had her vices. Her name wasn't actually Freesia, but when I was a baby I couldn't pronounce Theresa, so I would say Freesia—which also happened to be her favourite flower, so it worked nicely and stuck from then on. Freesia had a difficult life, but it never outwardly showed. I think as a child I was just enamoured by her ways, and even though I witnessed troubling things, I didn't understand them until well into adulthood. She was very camp and creative. An interior designer, who mainly worked in upholstery. She even upholstered some of the curtains in Buckingham Palace: that was her claim to fame. I always remember going into her Victorian townhouse as a child. Straight in, stairway immediately on your right, and then on the left, was a room filled to the brim of rolls of fabric. There were curtains everywhere and desks with sewing machines. In hindsight it was probably a small room, but it felt huge to me as a little boy. I can still remember the smell of dusty fabric and smoke. She was a heavy smoker; she smoked cigarettes with a cigarette holder, like Cruella DeVil. She was married, when I was a child, to a man called David. David and I shared a birthday. 27th April. He was so naughty, so funny. He was just a loveable, cheeky guy. He was also a junkie. A heroin addict to be precise. I remember finding orange syringe lids in the sofa at their house when I was a kid, 'Freesia what's this?' I'd ask, holding one up in the air. 'Nothing Sammy,' she'd say, gently taking it

off me. I had no clue about any of that when I was a kid, but I also did know he was a heroin addict. My mum had told me quite openly about the fact that he was a drug user. I never really knew what it meant, I just knew it wasn't good. I would spend quite a bit of time at their house now and then, staying over. They had a huge golden retriever who I adored. One time my auntie found me asleep curled up with the dog in the dog bed. She took lots of pictures and it was a story she loved to tell people at parties. Freesia was so creative, we would blow out eggs together and paint them at Easter. She decorated them as people, attaching accessories in meticulous ways, including gold earrings, head scarves, and eyelashes. I was fascinated. I still have some of those eggs to this day. Everything she did had an extra flair to it. Every birthday Freesia would send me a card, but it was always addressed to 'Master Samuel Morris Esq.'— in calligraphy. She was, I believe, my first artistic inspiration. I was utterly in awe of her, and how she used to express herself. I found out later in life that her house was raided by police once, for heroin. I don't think she used, but David would invite friends over, so the house, and subsequently her place of business, ended up becoming some sort of drug den. Freesia had MS. She found out in her twenties when she woke up blind one day. So she was always slightly fragile in the way she moved. I never saw her fragility so much when I was younger because I was distracted—dazzled— by her flamboyant fashion sense, her glamorous nails and colourful make up. She was very adamant on being glamorous at all times. Not in a stereotypical sense: she was always an outlier. Even on her wedding day, she wore a cute two piece, with a huge hat. It was fabulous, and even now, I think, totally timeless. I also found out later in life that when she was a teenager she became impregnated, and had to have a backstreet abortion— one that nearly killed her. A friend who found her

described it as a 'bloodbath.' Horrific circumstances. Then in her thirties she had a cancer in her uterus, and had to have a full hysterectomy, before she'd had the opportunity to have any children herself. When you saw this woman, who was so well presented, artistic, charismatic, you'd never believe the trauma she'd been through. Her interior design business ended up eventually going under. I don't think my uncle David helped, in fact I think he played a huge part in that. They did end up getting divorced. I never saw David again after the age of about 10. When I was in my teens my mum went to visit him on his deathbed. 'How the fuck did you manage to live this long?' she jested with him. 'God knows! Run out of veins to inject! Had to start putting it in my cock,' he laughed. Drugs don't make people bad—not by themselves anyway—he was the first person that taught me that. He told my mum that he'd always look over me on our birthday, and I take a lot of peace and gratitude in that. He died shortly after my mum's visit. My auntie Freesia married again, this time to a man much more troublesome. She wasn't great at picking men. I didn't know too much about this one, just that he wasn't good. I think he was potentially involved in some dodgy stuff. They moved to a new house, and it was always full of strange antiques and interesting collectibles: boxes of jewellery, shelves of candelabras etc. I have no idea how those things came into their possession, but it was very back-alley-Fagin-from-Oliver stuff. I didn't ask questions, I just remember being fascinated by all the things they had. At this point my aunt became more fragile: she couldn't walk without a stick, her style had changed slightly, and although she always smoked before, it went from looking like a fancy accessory, to a necessity. This new man ended up taking pretty much everything from her. He took her house, all the money she'd had left from her business, it was pretty much all gone. I mean, a lot of it was

already gone from David, shooting it up, but this guy took whatever was left. Fast forward to circa 2014, and Freesia is now living in a flat in North London. She can't get around unless she's in a wheelchair, and she has a full time carer. She was happy about this new flat she moved in to, I think the council had allocated it to her. It backed onto a lake and a deer always came to visit her. She quickly learned how to use Facebook, and would often post pictures of the deer, of herself feeding them and speaking to them. For her age she mastered Facebook pretty quickly, which didn't surprise me about her. She was always vibrating on a different wavelength to most. She'd often comment on my pictures, and send me messages. However she was still a traditionalist at heart, not a birthday would go by without a card addressed to 'Master Samuel Morris Esq.' — in calligraphy ink. We found out that she had cancer again, and this time it seemed to be a particularly bad one. We didn't know the exact details, but at one point she was admitted into hospital. I joined my mum one day, with my sister, to go visit her. She was always putting on a brave face, and to be honest, I think she hated me seeing her in that environment; she had no control over how she looked and she had to submit herself to being a patient, which I could tell she hated. Whilst we were sat by her bedside, my mum went to speak to a nurse, to find out more about what was going on. My auntie didn't have any other next of kin anymore: her mum (my nan) had already died, she had no husband and no children, so her sister (my mum) automatically stepped into the role. My sister and I stayed with my aunt whilst my mum spoke with a doctor. It wasn't good news. Upon my mum returning she sat down, opposite Freesia, and held her hands. I think at this point my sister and I should've left. I don't know why my mum didn't ask us to, but we ended up staying present for something that was not appropriate. 'So, what's…what is it?' Freesia asked my mum. 'It's not

good,' my mum said softly whilst shaking her head, holding back tears. 'Oh, where is it?' Freesia asked. 'It's everywhere,' My mum replied, talking about the cancer. There was a silence, and my auntie looked at me and smiled, then looked back at my mum and said 'well... that's shit.' My mum's face cracked and she put her arms around her sister. They held each other, my mum silently sobbing, stifling her tears on her shoulder. My sister and I simply sat there, holding back tears ourselves, not knowing what to do or what to say. They pulled apart, and my aunt said 'how long?' And my mum replied 'about 6 months.'

That afternoon, I thought at the time, would be one of my most life altering moments. I wasn't prepared for it at the time, and it was incredibly upsetting and difficult to process. I didn't think things could've gotten more traumatic, but somehow they did.

Shortly after this hospital visit my auntie went home. She had a full time carer, and was mostly being looked after in end of life care. One day my whole family had arranged to go down to Freesia's flat. We arrived and there was a pair of patio windows to the front of her flat on the ground floor. I went up and looked in through a gap in the curtains. I could see her asleep in a chair. I banged on the window, but she didn't move. My sisters were behind me, and the more I looked I could see something wasn't right. I told my sisters to go back and called my dad over to tell him. My parents had keys to the flat, so they went in and the rest of us tentatively followed. Again, I don't think this was appropriate, and we should've stayed in the car. Maybe not me, but definitely my younger sisters, youngest of which was 11 at the time. We walked into her flat, and was met by an awful odour of human faeces. As we entered the living room Freesia was sat, slumped into a chair, not moving. My

sisters and I stood in a row, on the side of the room, whilst my mum asked my dad to check if she was breathing. She thankfully was, but was totally unresponsive. My youngest sister started crying, and then so did the sister closest in age to her, and so my dad took both of them out of the room and into the kitchen. Left in the room with my aunt was then my mum, myself and my sister closest in age to me. Due to the amount of painkillers she was on for the cancer, she had fallen into a deep sleep, and was unable to control her bowel. My auntie was sitting in her own faeces, and it was also all over her hands. It was incredibly upsetting to see. My mum fetched a warm bowl of water and a flannel, knelt in front of her, sobbing, and started gently wiping the shit off of her unconscious sister's hands. As I watched the flannel rub over the end of my auntie Freesia's perfectly manicured red nails, I lost it. I could no longer be the stoic older brother and hold my emotions back. My face creased and my eyes filled with water. My sister standing next to me, still stoic until now, saw my face and became hysterical, running out of the room. The visual of my aunt that day will stay with me until I depart this earth. Never have I witnessed anything more sobering, real, or human in my life. It ripped through my heart. Our mortality. How humanity will always tear through beauty, no matter what. We gathered ourselves over the next hour, and then Freesia came round. She awoke, embarrassed to see us all sitting around her, quickly realising what had happened, and was humiliated. She was someone who took such pride in her appearance, and to be in such a vulnerable and human state in front of us was absolutely mortifying for her. She kept apologising. We encouraged her to stop, but she continued nonetheless. We must've all looked like we'd been crying I'm sure, but she never let on about it. She started talking about her funeral, and the funds. 'Go through my stuff and just eBay what you can, put all that junk towards the costs.'

She said. 'I did leave some stuff in that other room for you kids, but you don't have to have it if you don't want it. It's probably just all worthless junk anyway, you can just eBay it.' 'It's not junk, and I want it, I love your things Freesia,' I say. Not knowing what to say, but knowing my heart is breaking with every word that is coming out of her mouth. I didn't want her to think her stuff was worthless, I also hated the fact we were talking about her belongings like she was already in past tense. 'Well, we need to get rid of it, so go and get what you want and fill some boxes or whatever. I put some candlesticks and a lamp there for you Sammy.' We went to the back bedroom, and there was indeed a lot of things. Quite random things, and we saw the items that she'd allocated us each. There were boxes also set up for us to take home. With my auntie sitting in the other room, we filled the boxes of the things she'd asked us to take, and then walked them past her and to the car. I think I dissociated slightly that day, because even though by this point I was so disturbed by what we were doing, I didn't let it show, and if anything I masked it with humour with my sister, expressing how macabre the whole thing was. After a few hours, and a few cups of tea, we left. It was quiet drive home.

My auntie Freesia died a few weeks later. There wasn't many people at her funeral. No more than could fill half of one side of the pews. My heart broke again, seeing so few people for a full life. The curtain closed, and she was cremated. I was devastated after attending that funeral. I kept thinking about how she deserved better. I saw so much of myself in her. I started to think I would have the same destiny. I was the artistic outlier, making odd life choices. I was the queer son who wouldn't have the offspring to help when I eventually become infirm. I would have to burden a sibling with my death. This was my future. This was going to

be me. Freesia and I had so much in common, we gravitated towards each other. She was my godmother. When I was born, she held me and looked into my eyes for the first time, and said 'he's been here before.' She saw me like no one else saw me. She knew who I was. I think she knew I was queer, and a creative, and a trailblazer, from such a young age. She knew, which is why she nurtured it, with arts and flamboyance and love. She was dealt a difficult hand in life, but she prospered in her prime, against all odds and despite all the bullshit; she had fun, and always looked fucking fabulous. She was fearless, and for that reason she will always inspire me, but now, I'm just glad she's free.

Grubby Fingers

I can never seem to wash away the working class stench from my clothes. In the United Kingdom, here in this private members' club with a membership I worked fingers to the bone to earn (excuse the pun), I'm sat feeling out of place. A lower class crust sits upon me like a mould veneer that can be smelt from 10 metres away — at least that's what I imagine. It doesn't matter how much of a success I make of myself or how high I climb the proverbial ladder, no amount of scrubbing will remove the dirt behind my ears left from climbing up from the sewers of the proletariat. With that, and in tandem with being in the adult industry, the imposter syndrome I have in these elitist environments is palpable. The difference between me and 'them' is vast. 'New money' — this was a term I was taught growing up, about people who had made something of themselves but came from a working class background. 'New' money, almost as if it wasn't worth as much as 'old' money. Even in the same quantities, it was somehow less than, dirtier. Dirty money. That's what I spend here at this club. On a good day, there's an element of pride I take in it. Pride in my roots, pride that I broke one of the glass ceilings and fought for my seat at the table. Me being here is a protest in itself. I don't get comfortable. I'm ready for my seat to be pulled at any given moment. When they realise who I am and what I do, that they don't want 'that type' of person here. That I'll lose all the luxuries I've learnt to enjoy, like an inmate on day release.

Then I think, isn't that what I deserve, to stay in my place? So often it's my own ingrained thoughts and fears that tear each finger slowly from each rung of the ladder. When you do overcome your inner self-hatred, inculcated into you since birth, the gatekeepers sit atop, holding the steel manhole cover open encouraging you to climb; telling you you can make it if you try hard enough. Then when you finally get out at the top, after crawling out of the gutters, you sit down at the white linen covered table, lay your hands upon it, and leave filthy, oil-slicked handprints on the snowy fabric. Dirt sits beneath your fingernails, and as you pick up a glass of their finest wine, you see the hardened calluses on your knuckles from years of grafting your way to the table. Children run past me: rich parents bring their kids here after school for dinner. Well what is one to do as a working parent? They even do absurd child memberships. I don't belong here. I should be serving the tables, not sitting at them, I tell myself. Even if you work hard to convince 'them' you belong, they will always know you don't. It's all part of the Great British experience. With just one lilt of the accent in your voice, they know exactly who you are, where, and which classroom you've come from. But while I'm here I play the part, denying my background with every visit. I pretend I belong and try to enjoy myself, leaving dirty fingerprints wherever I go.

A Fag

I've gone through too many packs.

The stresses,

Passively taken out via drags of colourful cigarettes.

One quickly turns to 10,

As I kiss the gold foil,

And breathe in the deadly relief.

Escape.

I exhale.

My head spins and I feel a few inches above the ground.

For only seconds.

Back down. It burns my throat with a delicious destruction.

The coffee, liquor, cigarettes, and lines of white-wake up.

Their efforts are admirable,

Grafting for my relief.

Painting a disguise to shield myself from me.

If only a cigarette,

So elegant, such form.

Could offer such respite,

From the most brutal storm.

Porn

I've been watching porn for years. I think the first time I saw anything pornographic was a dirty magazine I found in my dad's bedside table drawer. I went looking for something to find and I did. It was mainly women obviously, but somehow the excitement of seeing something I shouldn't have got me hard nonetheless. I was about 11 at the time. I was always very sexual and keen to explore as a child. I was doing the whole 'I'll show you mine if you show me yours' from about 7 years old with my best girl friend. We used to compare pubes, and see who had got more. She always had. One time when we were left home alone on holiday, in a cabin in Scotland. We were about 8, both our parents had gone out, and we decided to play 'You Sexy Thing' by Hot Chocolate, take our clothes off and sort of just rub our naked bits together. We were both pre-pubescent so nothing actually went in anywhere. I was totally soft, and it was almost like we were playing pretend. It was naughty and funny, we giggled a lot. Coincidentally, just when we decided to go experiment and take our clothes off, we also decided to melt some chocolate in the microwave in a plastic bowl: no idea why, but we totally forgot about it. Our parents came home not long after. We frantically put our clothes back on, and rushed out into the living room to pretend we hadn't left the sofa. They arrived to the smell of burning plastic and chocolate and smoke pouring out of the microwave. They went absolutely nuts at us for almost burning the

rental house down, but little did they know why we had actually forgotten about it. Them bollocking us about the chocolate was actually a relief, considering what they could've found us doing. I went on to experiment with quite a few girls growing up. My first kiss was when I was 11, with a girl at a school disco, we danced together, hands on hips, and then snogged. It was the first tongue I'd ever had in my mouth — and I loved it. She was a very pretty auburn haired girl with lots of freckles. I used to buy her gifts all the time and was totally besotted. We didn't last that long together, as I seemed to go from one girlfriend to another when I was a pre-teen. One could say I was quite the ladies man. At a family party once, with my 'hot chocolate' girlfriend, we snuck upstairs into my parent's bedroom and went digging through their drawers. I wanted to show her my dad's naughty magazine, full of all these naked ladies. Unfortunately, what we ended up finding instead was a big leather photo album, which happened to be my parents' homemade porn. We opened it, and both stood, looking through hundreds of pictures—mainly close ups—of my dad's dick, my mum's pussy, my dad's hard dick inside my mum's pussy, and endless other variations. My parent's homemade stuff ended up being my first real exposure to penetrative hardcore porn. Think of that what you will. I went on to experiment a lot more with girls, did the usual teenage things, snogged a bit, fingered some girls, and got wanked off. It was always through playing truth or dare or some other game at a sleepover which always led to nudity or a sexual activity. It wasn't until a little later that came the boy stuff. When I was about 12, there was a boy that I was friends with from school. We'd hang out a lot, talk girlfriends, quite often bunk off our first lesson at school to go get McDonald's breakfast. Typical schoolboy stuff. One night he came over to mine for a sleepover. A couple of girls were meant to come over that night too,

and we were both talking about how much fun it was going to be. Unfortunately, both the girls cancelled, and so we were left discussing what we were going to do. While he was over, we were playing PlayStation or something like that, when he asked if I'd ever rubbed my dick, and if I'd seen the white stuff come out. I hadn't and didn't have a clue what he was talking about. I'd gotten hard a bunch, but not done much with it. He wanted to show me and I just went with it. We both pulled out our dicks, and his was really thick. 'Your willy is like a huge thick sausage,' I said. 'Wow your dick is so skinny,' he said. Funny thing is, at the time I wasn't offended because I didn't know what a dick was 'supposed' to look like. In hindsight, I assume that I was very undeveloped, and he was probably quite a bit more developed than me. I know that my voice hadn't even broken at this point, so it was unsurprising. He told me to lie down, got on top of me, took my hard dick into his hand, and started wanking me off. I remember him being quite vigorous with it, and me just lying there having it done to me. Our faces would come really close while he was doing it but we never kissed because that was 'gay'. I started feeling like my body was gonna explode. All my blood rushed to my dick, and I suddenly felt something like pain. I freaked out and threw him off me. My dick was suddenly bright red, my legs went to jelly, and I had a weird rushing feeling all over my body I'd never had before. I grabbed a pillow and ran out of my bedroom down the hall, straight into the bathroom and ran my dick under the cold tap, trying to cool it down. I believe that this experience was my first orgasm. I saw him now and then again outside of school, and we would go on to experiment more together. Neither of us thought it was gay in any way whatsoever. Both of us still talked about girls, and had girlfriends. We never kissed because we always thought that would be gay; we just used to jerk each other's dicks, and somehow, in our

heads, that wasn't gay. After this first experience of 'cumming' I started to experiment with wanking by myself. I used to steal my dad's magazines. I'd grab one, climb up to the top of my bunk bed and then have a wank. Nothing would come out for ages. I think I would do this ritual of wanking for a good while before I actually cum. I would jerk and jerk, vigorously, like my friend taught me, then I'd climax but nothing would come out. At one point I actually remember pushing piss out when I reached a climax, thinking this was cum. I got my first computer around this age of sexual enlightenment and I suddenly then had access to the world of internet porn, and that world became my oyster. I remember that I started off searching very basic hot words: 'gay', 'gay sex', 'men naked,' but before I knew it I was looking at hardcore gay porn on a daily basis—and developing tastes. I remember the pain of waiting for the dial-up modem to work, waiting for pictures to load, section by section, while I jerked off under my desk, listening intently for my parent's footsteps up the stairs. I remember it used to take just the preview images on a site to get me off, and I was a particularly big fan of the porn studio, Sean Cody. I got into quite the rhythm of getting home after school, powering up the computer, getting online, and spending hours browsing porn. One night my 'hot chocolate' friend came over, when we were about 13, and my parents decided to ask her parents to show them how to look at the internet history on my computer. My parents weren't very computer literate, and this was something I had always used to my advantage up until this point. That night, I sat downstairs with my friend, a cold sweat upon me, whilst our parents disappeared into my bedroom to look through my computer. After an hour or so, whilst I was quietly hyperventilating downstairs, they all came down and her parents said they were going home. I knew what had happened, and that I was about to die, so I said goodbye to

my friend like it was my last. After they left, my parents went insane. They expressed their absolute horror and disgust, and told me I would be having my computer confiscated. I don't know if they would've been as disgusted if it had been straight porn they'd found on that computer. My mother kept saying things like 'we found things on there that your father and I wouldn't even watch. It was disgusting.' I think it's fair enough that a child should be protected from accessing this stuff. But the draconian way I was chastised and shamed, I believe, came from a place of homophobia. As an adult now, I do not agree with how this was handled by my parents, and I believe that this episode contributed significantly to the overall shame I dealt with while trying to come to terms with my sexuality. I was disgusting and should be ashamed for what I was caught doing— that was made clear. I didn't have my computer for a while and then when I was eventually given it back, I predictably, like an addict, went straight back to it. This time I had learned from my mistakes, and I now knew how to delete my internet history. I watched porn probably every night after school from the age of 14 onwards, then almost every day of my life ever since. My porn tastes, and my kinks and aesthetic desires, have evolved and changed throughout the years. The work I ended up coming to make was a product of my own tastes, expressing what I'd learnt, what I liked, and what I thought was missing. It was also an expression of me overcoming my own shame, shedding that which was inflicted upon me. I was a consumer of adult material from such a young age that it's almost no surprise it has ended up such a huge part of my identity as an adult. I can't even imagine my life without freedom of sexual expression: it's who I am. There is a great irony that my parents had such a visceral reaction to discovering my consumption of pornography as a young teen, and then later difficulties in navigating my work as an adult, when

one of my first exposures to adult material was their own homemade amateur porn. It was abundantly clear that both my parents were incredibly sexual people and it is no surprise I ended up the way I am. I gave up watching regular porn a while ago, It just doesn't have the same appeal anymore. I always try to seek out authenticity now. Webcam sites are surprisingly vanilla, but extremely sensual to me. Knowing that the person you're watching actually exists right now somewhere in the world on the other side of a webcam just gets me off in a different way. It's live and real—as real as porn gets. I find it really turns me on seeing them fumble and lose their 'sexy' facade during a live session, like when they forget they're on camera and they start examining their body for imperfections, or you see them touch themselves then subtly smell their fingers. It's the human moments that get me off. I find it very sexy to look at their cock while they adjust the camera or do something mundane like take a sip of water. It's just sitting there neglected and untouched, and when it goes from hard to soft it withers and wilts like a dying flower photographed in a time-lapse. It transforms into such an unthreatening form of itself that it's somehow sexier to me than a throbbing red weapon being aimed directly towards the camera. I find that a hard dick on camera, with a sort of relentlessly unchallenged sturdiness, is almost performative. It lacks humanness and vulnerability. The act of them massaging their dick from soft to hard, the process of it altering form, is so much hotter to me than the hard dick itself. The maintenance of the erection, the constant stroking with spit and lube. Seeing a man try for it, work for it, actively maintain it, recharge it. The guys who just sit on camera with a reliable and unrelenting hardon for hours don't interest me. It's boring. I don't want the act, the performance; I want the person, I want the struggle, I want to see the growth. The private parts of the human

that lie in front of that webcam lens are the sexiest parts to me — the things we don't let others see or know about, secret behaviours, sometimes hidden from even our partners. There are windows of moments in these live webcam sessions when the mask slips, and that's what gets me off. I wonder where the men are located, and if they're okay. The set ups of some of the 'bedrooms' are suspicious: red light district, porn set, fake boudoir vibes. Some of them are clearly straight, knowing that gay men are watching them and playing the part anyway. Some of them really overact, especially with those little pink vibrators that are stuck up their ass. Every time you tip it vibrates and some of them look like they're being electrocuted. When I tune in and start my jerk off sesh, I hope that I'll get lucky with my timing and sync my wank with the moment they're about to cum. Usually that's not the case, so when it happens it's a blessing. I don't want it to happen too quickly into my wank though, there needs to be a good minimum 10 minutes so I've built up to it enough. Though if I miss the money shot, watching them clean up their cum afterwards, with a tissue or a towel, rubbing their body down and wiping the head of their dick clean, is a big turn on to me anyway. Again, it's the human, honest part that does it for me. It's something you never see in commercial porn. I am just a visitor on these sites, I don't even have an account. Sometimes you get really into a guy and then they go into a private show and their camera just goes blank. That's frustrating, especially when you're like 80% there, and then you have to go back to the main page and find another cam to get you going. Dick goes soft, and you have to start building up your wank again, but serves me right for being cheap. I also like to give each of the models a back story—it helps me reach climax. I wonder if they've showered yet today or just woken up and turned on their cam for their morning wank. What do they smell like? Do they have another job?

What are their beliefs? For some of them it's a true performance: they have the whole thing down and rehearsed, the art of the tease and the suspense. They know just how much to show, and what to do, to get the most amount of viewers and tips. You don't want to give away too much because you won't get tips, but then you don't want to give too little because then you won't get the viewers. It's a tightrope walk.

Somewhere, a webcammer says 'come on boys, just 200 more tokens and you'll see me shoot lots of hot cum.' This one guy I'm jerking off to is gorgeous, with a very smooth athletic body and a beautiful dick. He has a long foreskin laying upon his thigh like a deflated balloon. I like the way it just lays there and then when he occasionally picks his dick up and slowly pulls the foreskin back and you see his glistening wet pink head, it's …I can't hold it in anymore. I've been edging for an hour or so already. I shoot into the carefully placed tissue next to me, a good few pumps. Convulse, curl my toes, stiffen, big breath. Wipe the end of my dick on the tissue. Chuck it across the room near the bathroom door. Close my laptop. Have a long sigh. Lie back, and go to sleep. A perfectly oiled machine. A lifetime of practice.

A Bit Of Fun

He was holding the two dogs back as he opened the large front door, which opened to a large foyer of the Georgian house. The entrance always had a grand bouquet of flowers in a vase placed upon a marble table, with fresh flowers replaced weekly by a florist. There was a huge bookcase to the right, with a few awards proudly on display upon shelves on the right-hand side. I was nervous and sweating as I stepped into his house, and felt like I brought the smell of the tube in with me. He kissed me on my lips. His face was soft and cushiony. Expensive cologne and a touch of alcohol wafted up into my nostrils, and by now this had become a comforting and familiar smell. He was almost twice my age. This was a fact always in the back of my mind, but something I didn't dwell on for too long. I adapted to it for the most part, though some days the gap felt wider than others. He was still getting ready, so invited me to follow him to the other side of his house to find a flashy suit jacket from his huge walk-in wardrobe. He'd bought two Georgian houses, created a glass walkway between them which had a Japanese-style courtyard, and then gutted the second one and turned it into a vast atrium. The first floor of the atrium contained basically nothing but expensive art and a small wine bar; the ground floor showcased a walk-in wardrobe that was bigger than some master bedrooms, and finally an office, or as he liked to call it: his ego room. The ego room was full of magazine covers featuring him in frames and shelves full of awards.

Gold, bronze, and glass trophies. Hundreds of them, covering every single space in the room. While he went into his wardrobe room to try on jackets I would wander the ego room. Feeling his eyes staring down at me from every magazine on the wall. 'Cool. Are you ready to go?' he said from the other room. 'I sure am.' I always tried to act cool. Say cool things, act cool. Never too sassy, never too quick. Just the right amount of cool, that wouldn't be off-putting or offensive. I tried my best to relax around him, but the constant reminder that he was someone and I was no one was tangible in the most visceral way. He'd called a car which was waiting outside. The cars, usually black Mercedes, always had lux interiors with sweets and water bottles in the compartment. A far cry from an ordinary Uber, which was already a luxury for me outside of catching the tube. I'd really enjoy these moments of privacy between the two of us. Anywhere in public was difficult with him being so famous. In most restaurants, bars, or public spaces I was used to being thrust a phone and asked 'do you mind?' whilst they stood next to him grinning. I'd take a few pictures, give the phone back without receiving a thank you, and then we'd carry on our conversation before being interrupted again with another eager 'Hi! I'm so sorry but… do you mind?' The only respite we'd get from this was being in cars, or at home. I say home but it was always his place. He would never come to mine. I would occasionally invite him to things, but he'd simply smile, or giggle—enough to tell me that that was never going to happen. Him mingling with or being exposed to my friends was just something that was simply not on the table. I was his plus one, but he was never mine. This particular night we were going to a very exclusive party at Annabel's, a private members' club in London. I always dressed as well as my tight budget would allow, but at this point I was very poor. I would rummage through my wardrobe or put an outfit on my credit

card, to prepare for such events. In many ways I look back grateful for my naivety; if I had to attend such an event now I would be far more stressed about being better dressed. We entered the party and it was a star-studded event, and my date happened to be a celeb magnet. He knew everyone and everyone knew him. Upon entering, a very famous male pop star came up to say hi. I was introduced to him, he was very tall and very attentive. 'Hello Sam. How are you?' He stared into my eyes with such profound concentration, respect, and charisma. It made me blush and my belly tingle. They talked about coping with fame in front of me— I felt like a tourist in a gallery. No understanding of any of the art, but standing there and taking it in anyway. As they talked I looked about the room. I spotted a supermodel in the DJ booth, holding a headphone up to one ear, whilst the person next to her frantically kept control of the decks. I'm introduced to an actress, who was very sweet. 'Do you know who that is?' my date asks me. 'No idea.' I didn't have a clue. She was due to be very famous though apparently. Another famous female singer comes over to us, and as I'm being introduced to her and her date, my brain wanders and I'm looking across the room at the hot male pop star from earlier. Still thinking about our introduction. His eyes staring into my soul. 'He's not interested,' the singer behind me said. I spun my head round and realised I'd just ignored one of my favourite childhood pop stars as she was being introduced to me. 'Oh I'm so sorry,' I quickly replied. 'No worries,' she said, reaching out a hand which I took. 'Sam.' I smiled extra hard to overcompensate. I was so on edge. This wasn't the first event I'd been to as his date, they were becoming more regular. Around one a week. I was introduced to friends, celebs, colleagues, but there was always something behind their eyes that saw me as something I didn't see myself as at the time. I felt quite innocent in my dating this man. I was well aware of the

benefits that came with it. Who wouldn't love being whisked off to fancy restaurants, red carpet events and premieres, and introduced to A-list celebrities, but to be honest I did really like this man. He made me laugh.

We had a shared common sense, and a similar opinion on world events, politics and moral values. We could hold long and deep conversations together that I found stimulating and nourishing. So despite all the showboating around us, his company was special to me. I also admired him, and was excited by what he'd achieved. It inspired me, made me want to learn more about him. Be more like him. I wanted to have what he had one day. I used to feel uncomfortable with him picking up the bill after every meal. I urged him after dinner one day to let me pay, but he insisted otherwise. 'Listen. Money isn't an issue for me,' he began. 'I'd rather we ate in places that I liked and I can cover that. I don't want you to struggle and feel like you have to pay for that.' I understood what he meant, but it didn't make me feel good. I felt kept and paid for, which was never something I'd aspired to be. We continued this love affair for a few months. It was usually once a week, I'd go to his, get ready, drink a bit, then head to an event. From the event we'd go for dinner, then go back to his. Usually to drink even more. The man could drink. He could drink me under a table. We would usually, on an evening, sit on the sofa in his atrium, chatting over a bottle of white wine from his bar, while large pieces of Haring or LaChapelle looked down upon us. One time our kissing led us down the stairs and into his ego room. I was quickly on my knees sucking his cock, as he stood looking up at a wall of pictures of himself and all his awards, climaxing in my mouth. Interpret that how you will. After a couple of months of this back and forth between us, I started to feel more attached. I would look forward to

seeing him weekly. Sometimes it was all I could think about. I would tell my friends all about him, and he was on my mind a lot. One particular night we ended up at an after party. The alcohol was generously and freely flowing for hours, and like most other parties I was surrounded by celebrities again. I got extremely drunk and danced with a lot of them, I was taking silly selfies and having a ball. I was introduced to a famous chef. My date was abruptly whisked away by someone else—as if like being caught in a vacuum, there was myself and this chef standing next to each other in perfect silence. I couldn't, and still cannot, think of a single thing in common between us, and so the energy was suddenly a threatening level of uncomfortable. 'How long have you two known each other?' she asked. Very sweetly. I thanked the heavens that she broke the silence. We then had a little back and forth and laughed a bit; she was quite funny, and we actually seemed to have a little banter. I drank and drank at that party. I often use alcohol as a way to cope with social situations: the more intense they are, or the more insecure I'm feeling, the more I drink. On that particular night I seriously drank. We decided to leave and when we got back to his, we drank even more. By this point I was absolutely plastered. We kissed and fooled around pretty much all over his house, but my memory from that night is sort of obfuscated. I seem to remember kissing him at one point in his kitchen, pushing him up against a wall, and probably saying some stuff I would come to regret. Not necessarily bad things, just a few things that would show my age, and that he probably wasn't expecting to hear. We went up to his bedroom and fucked. He would hold onto the headboard as he pushed into me, and with every breathless thrust, I was reminded he was twice my age. We finished and went to sleep. I awoke to the overwhelming need to vomit. I ran from the bedroom naked, downstairs to a nearby toilet. I didn't want to go to the bathroom

across the hall from his bedroom as I was scared in the moment that he would hear me. I was still so bothered about his perception of me. I burst through the toilet door and projectile vomited all over the toilet. It kept coming and coming. When finally given some respite, I stopped, wiping the tears from my eyes. Though the room was still spinning, I surveyed that I'd vomited all over my legs, feet and the floor. I was then frantically, and disorientedly , wiping down the vomit off myself in the small sink of the toilet room and cleaning the floor with toilet tissue. This violent crash down to reality felt like the true me. It was frightening in the moment, how the truth had burst out of me so aggressively, so literally, and with such force. It felt like I couldn't keep up with him and I shouldn't have tried. I also shouldn't have drank so much in the attempt to become someone else, to try and fit in in his world; a world I wasn't a part of. I took my broken self back to bed and crawled nauseously under the covers. The following morning I woke up alone to a splitting headache and a bone-dry mouth. He had drank just as much, if not more than me, and had woken up early (as usual) to walk the dogs and go to the gym. I dragged myself out of bed and wandered over to his huge bathroom to sit under his rain shower and attempt to disassociate for a while. I sat on the floor, my arms wrapped around my knees, and let the heavy water flow over me. I felt such shame and embarrassment, and sadness. I had to get out of the house before he got back, so I pulled myself together and got dressed. His bathroom counter was like a cosmetics counter in Harrods. I'd always put a bit of everything on my face and spray myself with something when I was at his. It was a time to treat myself to things I couldn't afford. I then grabbed my bag and left. I sat on the tube home feeling heavy. Back to my reality. I went home and got straight into bed. I stayed there for a day. A week came around and he invited me for dinner. We arranged to

meet at a restaurant in Shoreditch. When I turned up, he was already sitting at the table. He seemed frostier than usual. There wasn't our usual rapport, it felt almost formal. We ordered food and drinks, and he turned to me quite abruptly, without any of the hesitation of someone my age. It felt very much like someone senior to me wanting to address something to someone junior. 'Look. We've had a lot of fun, but we should probably stop before this becomes a bit messy. Don't you think?' A part of me was crushed, but another part of me agreed with him. I smiled and nodded. 'Yeah you're right,' I said. 'It's just the other night, and I know you were very drunk, but you said something that worried me a little' he said. 'Oh, did I?' I said, suddenly panicking at what on earth I'd said. 'Yes, you called me your boyfriend.' He said. I hadn't remembered this, and I suddenly felt very small and embarrassed. 'Oh, I don't …' I said. 'It's fine,' he interrupted, 'don't worry about it. I just would rather nip this in the bud now before you get hurt. You know? We've had fun, but we have to be realistic, with the age gap and everything, you know, come on… it's not going to go anywhere more than here.' I sat there nodding and smiling. I agreed with him but I guess I'd been in denial. I had believed somewhat that we had something, and I think maybe I'd been carried away with all the blinding lights around us, enough that I'd lost clarity in the smaller picture inside of that. 'I totally get it and I'm sorry for saying that. Maybe I just got a bit carried away, but I get it, and agree with you.' I said. 'Phew. Well that's all good then. Just don't want anyone to get hurt. Do you want another drink?' He smiled and moved the conversation on to pleasantries just as quickly as he'd dropped the bomb that this would be our last dinner, and it indeed was. I never saw him again after that. I write this a decade later, after a lot of self-work, growth and change. I see this younger self and feel compassion because I was just so desperate to be

seen by someone, that in the process I actually got swept away and lost in a fantasy—I think in many ways we were both living in one. He had the fantasy of dating someone young and sexy, with little to no attachment, and I had the fantasy of being the boyfriend of a very famous man. I got to play pretend for a while, and so did he. In the end there was an amicable understanding that this unspoken agreement didn't have substance and would eventually run its course. I think it would be easy to reappraise this relationship now with a more critical gaze, but for me I'll simply take it for what it was: a bit of fun?

ACT II

Shame

You know, shame is something that you become so familiar with that it sort of becomes part of your identity. You don't even realise you might feel shame anymore because you've created so many coping mechanisms to cover it up, that it becomes a personality trait. The first conscious shame I felt was probably when I started realising I was gay. In all honesty, I was pretty repulsed by this discovery and I sort of wore shame as a badge of honour. I became more homophobic to disguise my discovery. I ran further away from who I was than I ever did before. You'd think coming out at a theatre school would be easy, but in some ways the overcompensating toxic masculinity from the straight boys made it even worse. I left school at 16 and went to dance college. I didn't really want to go to a dance school; I always considered myself more of an actor than anything else, and just looking at the prospectuses of these colleges, with all these gay boys in ballet tights with their dicks bulging out, was enough to make homophobic, closeted, 16 year old me want to dive off a cliff. I don't really remember having much of a choice though. I was offered a full scholarship on the day of my audition and with one look from my mum that was my decision made. So I enrolled. Ballet class everyday at 8.45am. 5 days a week. 16 years old, skinny as a rake, my voice had only dropped practically a few months before, and here I was standing in tights and a vest, practically naked, in front of a giant mirror everyday. 'CHIN UP, ARNIE!' my ballet

teacher would yell at me. Arnie as in Arnold Schwarzenegger. A sarcastic little jibe to poke fun at how skinny I was. We were all lined up sometimes in class, in front of the mirror, and one of the dance directors would go along the line one by one and, for lack of a better term, say something they didn't like about each of us. After one of the girls in my class started to cry the director said 'Yeah I'd be crying if I saw that in the mirror too.' It's a miracle most of us made it through that place alive. At that point in my life, I'd just recently stopped working professionally in the West End. When my voice broke I was off the market for child work in musical theatre, so I was sort thrown to the gutter, headfirst into the industry's…system I guess, to start my training for adulthood. It was a harsh reality to face, and quite quickly obvious that the shy and quiet demeanour that had worked for me as a child would no longer get me anywhere as an adult. 'You're a man, not a mouse. Grow up!' they yelled at me. 'Did you eat anything over the Christmas break? You look so thin. Disgusting!' My head of ballet greeted me with that line one January morning. By this point in my life I was extremely tired. I'd given years of my childhood working for an industry that gave me nothing back. Thrown back down the hill and forced to start climbing again. Hurling abuse at me with every foot I placed in front of the other. I was so fucking tired. Literally. My mum had also just recently had another baby. My youngest sister. My mum was 45 years old and, despite her better hopes, she became pretty sick afterwards. My mum didn't know what was wrong. Nobody did. She just became totally incapacitated. She stayed in bed and didn't move—for months. We had a newborn baby in the house, that I had to then help co-raise. I lived miles from my college, so I would get up at 6am to leave, travel for 2 hours, dance for 9 hours, travel back home for 2 hours, and get home at 8pm. If my dad was working late it would be

my duty to change the baby, feed the baby, put the baby to sleep. I would rock her in my arms and sing 'Rock a bye baby, on a tree top,' to be specific. One night around midnight we'd run out of pre-pumped breast milk and had no formula, and my mum was too ill to move from the bed. My dad had to drive to the nearest 24 hour supermarket to buy some, which was about 45 minutes away. The baby screamed. She screamed until she was blue. I walked with her in my arms, rocking her, handing her back and forth between my 10 year old sister and I. Both of us were hardly able to keep our eyes open ourselves. Meanwhile my mother slept upstairs with 2 breasts full of milk. She'd convinced herself she had mercury poisoning from her tooth fillings. She'd read somewhere this could happen, and had convinced herself that this was what was making her ill. She would make me do research on the computer and I would sit up late at night trying to find answers, heading down all sorts of medical rabbit holes, trying to find an explanation for her. My mum had always been eccentric in her beliefs, and reactions. After 9/11 she made me travel to school in London with a biological warfare gas mask she'd imported from China and made me carry it in my school bag every day. Can you imagine me ever actually using that? Sitting on the tube, smelling something odd and putting on a gas mask. People would freak the fuck out and I'd probably get killed. Plus I'm sure most chemical warfare gases are odourless anyway, so I'm not sure when she was thinking this 13 year old would suddenly know when to put on a gas mask. It was absolutely ludicrous, but I didn't have a say. Had to make room for it in my bag everyday, and carry it about with me everywhere. Books, check, lunchbox, check, military-grade chemical warfare gas mask, check. You'd think I lived in fucking Pripyat. I got used to this sort of hysteria throughout my life. It was perfectly ordinary that the worst case scenario was the first destination.

So instead of her getting a diagnosis of postnatal depression, which is what came a few years later and made some sense for a 45 year old woman having a baby, she remained incapacitated for over a year in bed, convincing herself and everyone around her she had mercury poisoning. It was a very difficult time for me. I burst into tears in front of two friends at college one day on my lunch break. 'Oh my god Sam what's wrong?' a friend asked. 'I...I think my mum is dying ... of a mystery illness of some kind. We don't know what's wrong. But I'm having to juggle being here, with raising a baby, and it's just a lot to deal with right now.' I cried. This went on for a while and during this time I was coming to terms with my sexuality. I would travel to London to meet men in private that I'd met online. I even started secretly fucking the college physiotherapist who was 15 years older than me. I would meet him downstairs at the physiotherapy room at 6pm, and have sex with him on the massage table. Other days I would go to his house while his husband was at work. Unethical and inappropriate doesn't even come close to how I feel about this now, I wasn't thinking, because I had no fucking time or space to think. However, I was the teenager, and he the adult, so I forgive myself for trying to discover myself in the midst of a huge mess. I had a high achieving couple of years studying at that dance school. I was seen as a promising young talent. I had real potential. Good reports and in all the top sets. But I just wanted to be anywhere but there. I just wanted to be free. Free to live, and explore, and find myself. Drama and chaos was everywhere I turned. I couldn't escape it, unless I escaped it. I started skipping classes because I couldn't get out of bed anymore, or I'd skip classes at the end of the day because I was totally uninterested and just wanted to leave. I made it into my third year of college and then got into a fight with one of the college administrators. I had a very public burnout and

meltdown, in front of many other students. The college never gave us any rehearsal or practice space, so we would often find corridors or other spaces to make things work, in preparation for assessments or shows. This one particular time we were rehearsing at the bottom of a unused stairwell, as was another more favourited student. The administrator came up to me specifically and said I wasn't able to rehearse there. I asked her if she would ask this other student to stop also, and she argued that she was only talking to me, and so I basically told her to go fuck herself. I was tired and had reached my limit. I was very alone, struggling, and in hindsight I needed help. There was nobody to help me, and if anything I felt further bullied by the faculty of that college. I became a problem and I was constructively dismissed from the school not long after. They made me formally beg to stay, as I was only 3 months off my graduation and still wanted to receive my diploma. So I fulfilled their request, but they had privately already arranged with the in house choreographers that nobody was to cast me in anything in the graduation show. I had been institutionally made an outlier by default and I couldn't cope with the disappointment or shame. So I gave up and left. I was a college dropout. I never made my graduation. I was still awarded my diploma by the governing body (which is completely separate to the college). Luckily for me they had seen me in a show and felt I deserved my qualification. Not that a diploma in musical theatre means anything in the real world, but it was more about the principle. A lot of the other students in the college looked at me like some sort of badass during that time, and I guess I used that energy in the moment to empower me and laugh things off. Then when that buzz wore off, and I saw everyone in my year in their graduation pictures on Facebook, all I felt was shame; sad, lonely, angry, and ashamed.

A Friend

My relationship with my sister has always been a little fraught. She's always had a bit of an underlying resentment for me, probably for being dragged across the city in the back of a car when I was off doing my shows in the West End each night. Like me she was picked up from school, thrown in the back of a car and ferried across London, without even a show to go to. She also had a pretty turbulent relationship with my mum. Though she seemed to give as good as she got when she became a teen. There was one incident where my mum slapped my sister round the face, and so my sister slapped her back. My sister's strength was soon overpowered, however, her hand barely leaving my mother's cheek before she went flying across the room. My sister grew up pretty quickly though, largely through having a newborn in the house she was made to help care for at the age of 10, but also having an older brother who was so genuinely scared of everything that she had to speak for him. She learned to use her voice very young because I was too scared to use mine. This turned her into quite an authoritative and diplomatic adult. She went down a pretty serious academic route. A-levels, bachelors, masters. While I flailed around for the good part of a decade working out who I was and what I was meant to do, she looked at my path with a sense of trepidation and made decisions for herself to make sure she didn't go through the same. I didn't have a fucking clue what I was doing. After I fell out of college, I was lucky enough to get

an agent, but I just didn't book anything. I would audition and audition and nothing. Nobody wanted to work with me. I was so nervous going to auditions, sort of scarred by the rejection I experienced at college, and also working out how to navigate adulthood as an extremely shy individual—who's only skill was performing. Being shy and a performer is not an ideal combination. The transition from child actor to adult actor was turning out to be the stereotypically ugly path I'd seen with famous child stars. I did all sorts of shitty jobs in the meantime. I worked in a ceramic cafe. The cafe wasn't ceramic. It had ceramics in it. You painted them, while having a cappuccino. I would then gloss them, put them in the kiln, then make phone calls like 'Hi Debbie. You came into the ceramic cafe 6 weeks ago. You need to come collect the turquoise duck you painted.' Hated that job. I used to do a lot of shitty promo work too. I remember once giving out free lemons and limes for a vodka promotion. 'Now you can only give the fruit to adults. Ok? This is an alcohol promotion, so no children are to receive the free fruits,' the team leader would tell us in our briefing. As it turns out, citrus fruits are logistically a very difficult fruit to give out for free to the average pedestrian. I remember wheeling a huge barrel of limes back to the van at the end of the day, straight past a theatre that my friend from college was performing in at the time—her on the poster outside and me pushing a cart of leftover fruits past it, wondering where it all went wrong. I did a lot of extra work too, on films and TV. Hellish life. 4am wake ups. Standing in the cold for hours. I remember doing a day on The Bill. We were outside and it was below 0°C. The costume lady in a floor length ski coat with hand warmers in her pockets and her shoes, came over to me and said 'I'm gonna need to take your jumper off.' 'I don't think so,' I replied. 'I'm not really asking you, I'm telling you' she replied. 'And I'm telling you I'm not taking it off. Why don't you take

off that thermal ski coat?' I asked her. 'I'm not an extra,' she said. 'Well neither am I,' I responded. And then I walked straight off the set. I got dropped from that extra agency, unsurprisingly. But it was worth it for how liberating it felt at the time. Ironically, I once got a job working front of house at the Drury Lane theatre, whilst an Oliver revival was on there. I used to stand at the back of the auditorium, watching the kids half my age, performing everything I did 15 years prior. It was weird— and sad. I always thought I'd be famous, or be successful in some way when I grew up. Name up in lights and all that shit. Failing never really felt like an option. But standing there in my mid twenties with an ice cream tray strapped to the back of my neck, watching my childhood play out in front of me, was a sobering moment. I did win the prize for most ice cream sold in an interval though, so I guess my name did make it up onto at least one board at the Drury Lane. But do you know who was my biggest supporter, my biggest champion, the person that kept driving me forward and pushing me to carry on during all these shitty jobs? My mum. Once I'd left home, my relationship with her became much better. After her postnatal depression diagnosis, she was prescribed antidepressants that sort of managed to smooth out all of her jagged edges. She finally became consistent. Her moods were no longer volatile, and it seemed like only her good traits were left. We would laugh together, and talk for ages on the phone. We'd share stories and fears. I think I buried all the negative feelings I had for her as a child, in the hope that I would have a close and happy relationship with her as an adult. Pretending all the bad times didn't exist for the sake of being a happy son felt like the easiest route. That and I think she had genuinely convinced me that I had an amazing childhood. If I ever brought anything up it would be laughed off or I was gaslit about it. In any event, this avoidance seemed to work. We would go for dinner

together, to the theatre, even on holiday sometimes. Too much time used to send me over the edge a little bit, like any mum I guess, but this self-created picture—like she was this mum who had always been my best friend—was a constructed reality I was willing to live in. I never needed to face the shit from my childhood. I didn't feel scared of her anymore. The medication she was on ironed her out and made her feel safe to be around. During these years I confided in her a lot, she met all of my boyfriends and my friends, and became this sort of Jennifer Saunders in Absolutely Fabulous kind of character. She would get close to my friends, and spend nights drinking with them, long after I'd gone to bed. The meds she was on never seemed to change her charisma or her confidence, and all my friends were absolutely enamoured by her. I sort of unintentionally integrated her so deeply into my life that the boundaries of mum and friend had become blurry. My main vision of her now was solely the woman I'd sing Celine Dion with in the car - and I really loved it. I'd convinced myself in a way, into believing that my childhood was really happy, just a little unique, and my relationship with her had always been strong, stable and loving. It is very easy to believe what we want if we pursue it with enough fervour.

INTERLUDE II

The De(ntist)(vil)

I punched the apparatus out of my mouth and shot out of the seat like I'd just been electrocuted. I turned round to my dentist and nurse, mouths both agape, and said 'I'm done.' I waved my arms in the air as if swatting away flies. 'I cannot take anymore. I'm done.' I grabbed my belongings and left. I'd been doing Invisalign for a few years as I wanted to improve my smile. I hadn't quite anticipated how traumatic the process was going to be, and how often I would have to be in the dentist's chair facing unresolved childhood dental trauma. There is this teeth shaving thing they do as part of the Invisalign process, and it is particularly horrific. They file down the bone between your teeth with an electric sandpaper disc, to create space to allow movement. No numbing, they just go straight in. It is what I imagine to be a mediaeval level of discomfort. I often felt like I was in some sort of torture porn horror movie franchise while in the chair. I would lie there thinking 'is having straight teeth really fucking worth it?! For THIS!'

When I was two years old I fell up a step and landed on my open mouth. Top teeth full on kissed the concrete. Blood everywhere, I smashed my teeth to bits and had to undergo surgery to have shards of teeth removed. After that the remnants of baby teeth left in my head became infected and then those ones had to be removed in a second operation. Two general anaesthetics at the age of two. If asked what my earliest

memory is, it's doctors in white coats, bright lights and long corridors, and being handed bags of my teeth with illustrations of tooth fairies on. There were so many teeth in these bags. Each small bag could be shaken like a castanet. I still have them, stuck inside the pages of my baby book. Most kids get excited for the tooth fairy to pay them a visit. Pop a little tooth under the pillow, wake up with a pound. My tooth fairy was a psychopath. A genocidal maniac. The Bone Collector. She swept in and mugged me for everything I had. My baby book, instead of being a sweet flip through of fond memories, is like something witnessed behind glass cabinets of the Hunterian Museum inside the Royal College of Surgeons. Needless to say I'm not a fan of the dentist, nor the tooth fairy, and I avoid both at all costs. I did quit Invisalign, it took 2 years of stamina to get as far as I did. There's lots more my dentist wanted to do, but I couldn't possibly take anymore brutality. For now, I will just force myself to find love in the smile I have.

That or just keep my mouth closed.

Safe Places and
Golden Arches

I bought a dragonfly necklace at a small shop in Barcelona. It was a simple gold chain, with a golden pendant hanging off it, a turquoise face and a gold dragonfly fixed upon it. I've always loved dragonflies. They're one of nature's hidden treasures, a little dinosaur amongst us, and they always emerge randomly in places and are gone as quickly as they came. You have to enjoy their presence for just a moment before they disappear. Fleeting and marvellous. A bit like a good mood for me. Have to savour it while it's here. I've been terribly depressed. Treading old ground in Barcelona sent me into a darkly nostalgic mindset, forcing me to reflect on what it is I'd achieved in the years since I visited here last. I came here for a break, I thought I needed the holiday, and hadn't anticipated the introspection that I'd force upon myself. In walking the streets of Barcelona I reminded myself how much I hate the iconic layout of the angular crosswalks between the buildings in Eixample, which mean you take twice as long to get anywhere on foot. I walk past the same places from three years ago. The same school, the Catholic Church, the sandwich shop called SandwiChez which always made me smile. A few businesses had closed up, I assume they hadn't survived the pandemic. Quite a bit has changed, but I hadn't. I still gravitated to the same places. No matter where I am in the world I'll navigate the nearest Starbucks. It's a familiarity thing. It calms my anxiety. I know it's not good for me,

and I know it's not really à la mode to drink American coffee in every country I visit, but when I drink it it tastes like security and safety. Just ordering what I want, holding it, tasting it, gives me a sense of calm in my day. The same as McDonald's, wherever you go it will taste like home. Your mind can rest for a moment to refuel. That alone is enough to calm my nerves. When I was a child my dad would wake me up on a Sunday morning sometimes and whisper 'McDonald's breakfast?' I would leap out of bed and then we'd drive over and get their big breakfast tray meal. I remember being so excited opening that yellow lid. My Nan also used to take me to McDonald's a lot. She didn't like anything other than the Filet-O-Fish®, so she would just get that. I used to tug on her side at the counter, give her a look and subtle point, she would smile and nod, then tell the cashier that I wanted the girls toy with my happy meal—always discreetly as to not embarrass me. McDonald's only brings happy memories back for me. I know it's not good for my body, the environment, et al, but for my mind, it's good. It keeps me sane. Particularly in moments where I feel unrooted or lost, these places provide me a space that I feel at home in. Wherever I am. That I can disappear into.

I Know An Island, Too

There's lots of foolish things we do when we're young that we look back on and cringe about. Falling for that boy that was always clearly going to fuck us over. Certain hairstyles that we thought were very fun at the time. Facebook statuses written in the third person. For me however, one foolish thing stands out particularly clearly in my memory, and it's not so much simply cringe-inducing, but also rather quite frightening. When I was about 25, I was contacted by a choreographer. This particular choreographer had taken a liking to me in London when I was in my early twenties. I had attended one of his auditions, he favoured me considerably, and I didn't complain about it. This one audition I went along with my best friend. She had wanted to go, I hadn't so much, but as it was boys and girls, I went for moral support. In one part of the audition we had to get into a giant semicircle, and one by one, enter to freestyle to 4 Minutes by Madonna featuring Justin Timberlake and Timbaland. My friend had way too much energy, and rather than walk into the space, she nervously pirouetted forward, travelling across the room toward the judges panel like a tornado. It made me giggle quietly to myself whilst I was waiting for my turn. This freestyle choice of hers that day would provide a sense of comic amusement for the pair of us for years to come. I went into the space, and surprisingly nailed it. This era was a good moment for me in dance—I had just made it to the final twenty

boys in the original season of So You Think You Can Dance, and I was perfecting a strong technical commercial style. After a few failed years out of college, I seemed to be on a good path. After everyone finished dancing I was asked to stay for the recall, but my friend wasn't so lucky; ironic considering I'd only been there because of her. I stayed and the choreographer told me how sharp I was, and that I just needed to believe in myself a little more. I remember the excitement I felt. I wasn't often complimented as a dancer, and so it raised my self esteem for the next round. In the recall we stood in another semicircle; 10 boys, 10 girls, and once again, we freestyled one by one. In a truly savage twist, the girls had to put the boys into a line up, from 1 to 10, ranked from best dancer to worst dancer. Hideous and unnecessary. I, by my luck, was chosen by the girls as the best dancer. One of the few times I've been chosen as best in anything, so while I did feel sympathy for the boy chosen last, I also revelled in this moment for myself. The tables then flipped, the choreographer lined up the girls, and told the boys they could choose their partner, from 1 to 10. I got to choose first. I looked for the smallest girl in the line up. I knew we were going to do partner work, which wasn't my forte. I myself am only small, and was very skinny then, so I needed an easy ride. My choice however, backfired quite badly though as the girl I chose turned out to be pretty terrible, and didn't know how to carry her own body weight. It was a lesson learnt in not judging a book by its cover. However, I digress. The audition itself isn't important in this story. I never ended up booking it, and although the audition raised my self esteem for a day—so much so I remember many details 10 years later—it didn't really amount to anything. Shortly after the audition, the choreographer friended me on Facebook. He was interested in keeping up with how I was getting along in the industry, and he reached out to compliment me on a great

audition and to give me some confidence tips. He told me I needed to believe in myself more, and so I appreciated this new connection. A few years passed and like many Facebook friends he was always loitering in the background of my account, liking a post now and then, maybe a comment, but no real important conversations or friendship developed. When I was about 25 he reached out, saying he had an interesting proposition. It was highly confidential and needed to be treated as such, so we would only speak about it via Skype or email.

Now, here I'm going to begin to tell you about something so far-fetched that it may almost read like a conspiracy theory. However, everything that I have written here (a lot of which is quoted) is verbatim.

'There is a weekend long party that happens three times a year—Independence Day, Halloween, and New Years Eve—on a remote private island in the Caribbean in which the world's most famous, and closeted gay men, pay for and attend, to essentially fulfil their erotic fantasies without being caught.' Ok. I read this email with my brows furrowed. I was wildly bemused by where this was going. 'I am part of the organisation team that facilitates scouting the models and talent for this island. We only hire actors or models for this as we can only bring people who have something to lose. The people who will attend this event that you will meet will change your life forever.' I scroll through this, shocked yet curious; my brain is like a sponge taking it all in. 'There is an opening and closing ceremony that will have someone of the world's most famous talent performing, which would also include you alongside.' Right. 'So here is what is unique and what we will need from you. All models and dancers involved in the opening and closing ceremony, will have to be on stage completely naked, and erect. You must be able to maintain an erection for the entire show. Is this

something you would be able to do?' Um. I read this, confused, unable to process what was being asked of me. Obviously, looking back at this now in my mid thirties I'm screaming at my younger self to close the laptop and run. Don't even listen to a minute longer of this shit, but I didn't, I carried on. Falling further into the trap. 'There are also erotic workshops on the island, in which we use the models on stage, to perform erotic acts. Is this something you'd be comfortable with?' My brain was doing backflips. 'You will make $15k for opening and closing ceremony. The male masturbation class: $17k. The Karma Sutra class: $20k for topping, $25k for bottoming, $30k for both. You will be paid in cash or wire in 3 instalments. The first when hired with contracts signed, the second at the start of rehearsals in LA, and the third at the end of the last performance. All of this is inclusive of a US O-1 Visa that will be organised for you by the important figurehead participants of the event.' At this point I was about minus £1k in my overdraft, with a maxed-out credit card, and hardly any work coming in. My safety at this point was so secondary to my need to survive. I wasn't even thinking clearly, I just knew this man, knew he was connected, and in a moment of madness I believed him. 'So what do you need from me?' I asked. I was then sent a list of instructions for how to proceed with my audition.

'Video Tips.

1st video - Slate.

Say your name and date standing totally nude and hard, show full body and both profiles and back, wait a beat between each position.

2nd Video - Erotic Dance

Dance totally nude and hard to a sexy song, tease and show off dick and ass, and do some floor work. Try and stay hard, so do what you need to do to keep it... porn, lube, or cock ring.

3rd video - Jack off

This is totally finding your inner porn star (make a solo porn) make sure u tease and give a dick and ass show, for example go on your knees ass to cam and arch your back like your being fucked, you can watch porn to keep you excited until climax.'

I was told that multiple UK dancers and actors had done this, and that's why they were working now in the United States. He said it was the only real way to get an easy O-1 visa, and get a foot in the industry by pleasing some of the industry's finest on a secluded island. Now I know, reader, what you are thinking. It's absolutely incredulous, quite clearly an extortion, but at that point in my life I was absolutely desperate, and the idea of escaping my situation clouded all logic and judgement. And to be frank, he definitely knew that. I'm embarrassed to say now that I did what he asked. I took the videos, and did exactly what he said, following all instructions as best I could. I sent them to him, and I'm sure he still has them to this day. Of course I was 'unsuccessful,' he said. 'The team' went over my tapes, but ultimately decided not to go with me because I said I wouldn't do full intercourse in one of their 'shows'.

The thing I've found hardest to wrap my head around years later, is that I had so clearly accepted in my mind that this was done simply to exploit

me, which is the most obvious scenario. Occam's razor. But then when the Jeffery Epstein scandal started publicly unravelling my immediate thought was single and troubling: I know of an island, too. Suddenly, all my thoughts were thrown into the air again. I've seen how powerful men behave on Fire Island, and I don't actually think it's so far-fetched to imagine that an island like that exists for powerful men. Other times, I think to myself 'Don't be ridiculous, this man was just doing this to extort videos and pictures out of you' — which is the most logical and clear reasoning. Regardless, I was exploited by someone I looked up to and trusted, and not for the last time. I was used for my body, and sadly believed it was going to be my ticket to somewhere better, somewhere with opportunity on the horizon. I feel embarrassed for myself even telling this story, but I also have compassion for my younger self who was simply desperate with no way out. Anyone offering him a ticket to anywhere would've had their hand bitten off. No matter where it lead to. I don't think I'll ever really know the truth, but I'm sure many others have this very same, very strange, and very sad story.

ACT III

Good Guys?

It took me a long time to find him. I had a lot of boyfriends through my twenties. A lot of toxic relationships. I contributed to a lot of the toxicity myself. I was so scared of losing lovers that I just lived in a constant state of fear, which inevitably scared them all away. I would love them so hard with such intensity, my candle burnt at both ends. I don't really feel like I had much going for me at this time: no proper job, or career, just some averagely good looks, a good sense of humour— enough to get some attention from boys. Being so unfulfilled in my career I had to get my kicks somewhere and it ended up always being from men. I had a lot of casual sex, and ended up in flings and relationships I couldn't sustain because I focused so much of my attention on them it would be overwhelming. I would become obsessive. I couldn't think of anything else and it would eventually flood the relationship with an inevitable dynamic imbalance. It would be forced to end shortly after it began. Then I would cry and cry for weeks, and then would attempt to heal my wounds with more men. It was really unhealthy. That being said, between the heartaches, I did really discover my passion for sex during my twenties. I rebelled totally against the internalised feelings of homophobia I had when I was a teenager and sprinted in the absolute opposite direction. I couldn't get enough of gay sex. I would be on Grindr almost everyday looking for dick. It was a drug. Talking to a stranger on an app, him giving me an address, me

turning up to a mystery location in the dark of night. The buzz of danger and excitement would make me shake, and that shake was a drug. A very addictive drug. Once I'd arrive and get to it, the sex was never as fulfilling as the build up. So I'd keep repeating it. For years. Sometimes I wondered if I was doing it because I loved sex, or if I just loved the buzz. I was desperate to feel something, to feel I existed. My whole childhood had been spent on a stage performing to crowds that fed me with a daily adrenaline rush, and my adulthood had thus far been filled with nothingness. I was suddenly invisible, a Mr. Cellophane character that needed attention like an addict needs his next hit. I was too scared of drugs for years, and my hangovers were far too brutal to become an alcoholic. So I became addicted to sex. Then I started taking my clothes off on the internet. I guess there was a new itch that needed to be scratched. It wasn't a quick progression, but a progression nonetheless. Started off with a few topless pictures, pictures in underwear. Then I was contacted by an anonymous account in Saudi Arabia who wanted to pay me £2000 to see me fully naked. Two grand to send him my nudes. I was absolutely buzzing. I was so fucking poor. Poor as shit. I had 2 grand maxed out on a credit card, well into my overdraft, which the bank was telling me they would be removing by £100 a month. I was going from job to job, my mental health was never stable enough to hold down a full time job for longer than a few months. So £2000 for some nudes? I did it, and it ended up opening the door to a lot more. I started getting approached by photographers to shoot with them nude. Started doing that. Fully naked. At first I was shy about showing my dick, but that soon became a nonissue. In fact I started to enjoy it. I wasn't embarrassed about my body, I knew I had good assets so was happy to show them off. I started to become an exhibitionist, and a popular one at that. It was the next chapter in my

sex addiction. Showing off my body became a new kink, but naively I hadn't thought about how this might attract predators, and make me the prey. There was one shoot I turned up to with an Italian fashion photographer. His work was amazing. I thought it was incredible that I was being asked to shoot with these talented people. I finally felt seen and I couldn't believe it. I felt noticed. After feeling invisible for so long, I was finally being given an opportunity. People admired my confidence and self expression, and there were suddenly many who wanted to work with me. It was evening by the time I arrived at this shoot. I followed a long set of winding corridors in a warehouse in East London and reached his studio. He was probably in his 60s, white beard, smelled of coffee and cigarettes. He asked me to take my clothes off and stand over by a plinth he'd set up with some spotlights shining upon it. At first I did a few poses, he told me to think of a Greek sculpture. So I posed and his camera snapped away. He told me to lean over the plinth. I did. I thought maybe he was going for something a little more editorial. He said lean further, more over it. 'Like this?' I was laying almost on top of it at this point, on my stomach, my legs dangling off the back. He said 'wait. Let me position you.' He came up behind me. My legs were hanging from the back of the plinth. He grabbed them, a thigh in each hand and pushed me further over, parting my legs more as he did so. My head was now hanging over the other side, my ass up on the edge of the box, exposed, and my legs hanging down. 'Better' he said. He stepped back and I heard him sigh, moan, and then grunt. I heard the zip on his jeans slide down. He then stepped forward, spread my ass open and put his face into my ass. I then felt his tongue slide into my hole. I could hear him behind me, his fist pounding against his groin whilst I just sort of laid there over the top of this plinth, like a dead body, as he ate my ass out. I couldn't really move, because I was

in a weird position, and also for the fact that I just froze. My mind had left my body at that point, and I was thinking about what was happening in an almost third person perspective. After a few minutes he asked me to get off and turn around. I clambered off the box, red marks across my stomach from the edges that had dug into my skin. I turned around and he was stood there, his belly hanging over his grey bush of pubic hair, and his small dick being jerked while staring straight at me. I just stood there not knowing where to look or what to do. He just stared at me. His eyes glazed. As if he was looking straight through me. I stood there naked, with no idea what to do next. Then he moaned, took two steps closer to me, and grunted. 'Ugh. Ugh.' He then came over me. His cum shot straight at my torso, and dripped down my groin and onto my feet. He let out a sigh, stepped back, and wiped the cum off his hand onto an old tea towel laying on a table by his side. He zipped up and turned around. 'All good,' he said. 'That's us done then. You can get dressed.' 'Thank you,' I said. He smiled and fumbled for another dirty towel to pass to me to wipe him off of me. I put my clothes back on, thanked him again, and briskly left the studio. It was dark outside so I called an Uber. On my way home I cried. As the yellow street lights flashed past me in quick succession, my vision blurred through the tears and all I could only see was a mirage of colours. I'd been excited to work with this man because I thought he admired my work or my beauty, but in that car on the way home I didn't feel special, or like a model, or someone he wanted to work with. I realised that he just wanted to fuck me. I was just a piece of meat, coerced under false pretences. A piece of meat, flung across a slab. That was just the start of many of these experiences; I'd not only started to attract them, but also expect them. I never fought back, I just started to grow a thicker skin. I coped with it and carried on. I

dissociated, separated myself from my body, and fed it to people on a platter. It made them happy when I performed and so I did it. I stopped being poor when I started doing adult work. The more hardcore you go the more money you make, and so I just kept going further. I was sexually assaulted by a lot more people. I was even raped once, but I made a lot of money, and became quite famous. Is this what they mean by selling your soul? I've always made my career seem very glamorous online, but I can confirm it hasn't always been as such. I'd talk with my mum sometimes about it, not giving the full details, but alluding to certain things that were going on in my life. She would say 'as long as you're not hurting anyone I will support you'. It turned out I was the one getting hurt, but I was so dissociated that it didn't seem that way. She would say she was proud of me, but I wasn't sure if it was just her way of trying to convince herself. Everything she cared about was for her own best interest and her ego. The more porn stuff I did the less it did for her image I guess. The more ashamed perhaps she became in private, even though she didn't say it to me. The more financially secure I became after choosing this line of work, the less I needed her money in times of trouble. This caused a distance between us because I'd finally flown the nest, which she interpreted as a rejection of her as a mother. There is nothing that a narcissist loves more than having and exerting control over you, particularly financially. I think there was an element of me feeling lost in the world, with this ambiguous hope of becoming an actor, that she liked being a part of. She still felt needed. She wanted to revel in the struggle, enjoy the rewards, and pick up the pieces when I fell. I was the Pinocchio to her Geppetto. Her love always felt like it was about control. Once I met my boyfriend, he accepted what I did and didn't judge me for it. He cared for me and wanted what was best for me, without trying to change me. His love language was

almost just trying to make life easier for me. It was the first step of finding my new family in life. It wasn't easy for me to let him in. I really struggled at first, because I was so conditioned to falling for the bad guys, but this particular time there was something in my gut that was telling me it was time to let a good guy in—and so I did.

Changes

My mum didn't meet my boyfriend for a while actually. Every time an opportunity came up for them to meet, something stood in the way. Either she was off on holiday, or he was working. It was odd really. She'd always met my other boyfriends, and she kept saying she wanted to meet this one. 'Do I need to buy a hat?' she used to ask, implying a wedding was around the corner. I'm a bit too atypical for a marriage I think, but ya never know. When the pandemic first broke I was mid-travel to France, to spend what was meant to be just a weekend with my boyfriend. I ended up spending a two month-long lockdown there. It was miles from home, but I was with him, and I felt less alone. It was quite a lot of pressure to be locked down together for so long, but we made it work. We did all the usual zoom quizzes and I chatted with friends about how they were getting on. My mum had started to occasionally question what was going on in the world. Not like the rest of us, however, with logical curiosity. She had more-than-average concern and some theories that were out of the ordinary. We were still speaking quite a bit on the phone at this point, but I would find that she would go off on very tiresome tangents. Telling me how she didn't trust the government and that she felt there was more to this pandemic than met the eye. Nothing too crazy to start with, general gossipy stuff. You could still speak to her about other things... until you couldn't. One of the last phone calls we had she just wouldn't stop talking about Hillary

Clinton and other celebrities injecting themselves with adrenochrome—a chemical that's supposedly taken from the blood of babies; other stuff about her alleged involvement in the Epstein island debacle, and how the pandemic was a big cover up so the elite could carry on trafficking children and babies. It was some seriously far-out stuff, things that maybe you'd throw about with friends after a few joints but way too heavy to deal with on a conversational daily basis during the lockdown. This became a regular thing and you couldn't talk to her anymore, about anything, without her taking you down some insufferable and nonsensical rabbit hole. I was fearful. I recognised this behaviour, and immediately knew that the woman whose baby I had raised when I was 16—while she laid upstairs in bed convinced she had mercury poisoning—was back. She had become extremely paranoid and illogical again. I became worried and I told my dad to keep an eye on her social media use. She was spending every single hour on facebook. Reading all sorts of crazy shit. It had totally infiltrated her brain, and we just couldn't seem to break through to her anymore. There was an attempt to create a balance of some sort for a while, between the conspiracies and our family relationships, but then it all became flooded with 'the movement'. A normal conversation was no longer possible. She was lost to it, like a cult. It was the most extreme I'd ever known her, and whilst I didn't recognise her or her views, the histrionic and aggressive behaviour she was expressing was familiar to me. A lot of conspiracy theories are a pipeline to right wing and fascist beliefs, and when she openly started to align with these I couldn't cope with it anymore. Her views became so offensive and extreme, and were everything I stood against. The woman I used to fear as a child had returned, and she was angry. I started to go into my shell. To self-protect. Confused and scared. Not knowing which way to turn. I would confront her about the

offensive things she was posting online, and she would get incensed and highly defensive. She started blocking all of her friends on Facebook. Her relationships were dropping like flies. Family friends we'd known for decades, blocked, all because they also didn't agree with what she was posting. They would reach out to me for answers, but I was just as lost as them. Then she blocked me. Most of the communication we had was over Facebook messenger, especially whilst I lived abroad. Messages every now and then, advice, catch ups, recipes. The usual mum and child stuff. Then nothing. I was blocked. My mum used to post pictures of us as children on her Facebook, family photos of old relatives, my deceased grandparents. I could no longer see any of it. I hadn't saved any of them. It was upsetting. Shortly after this she set up a Twitter account and immediately started growing a following. Inciting hatred online for all sorts of things. Spreading misinformation and engaging regularly with conspiracy leaders. She became totally anti-vaccine and from that point, pretty much the only communication I had with her was when she would beg me to promise I'd never get the vaccine. I told her there wasn't a chance in hell I'd not get it. I'd be the first in line if it meant I could have my life back. I wasn't afraid of modern science. I am a realist, and I subscribe to evidence-based logic. I trust academics. As a gay man, I am reminded of a previous pandemic, daily, by the blue PrEP pill I have to take to protect myself from it, as it still isn't over. By the time I was eventually offered the vaccine by the NHS, which took a while being in the younger and healthier bracket, I took it. She found out, and she immediately disowned me. What little communication that was left, ceased, and the only things I saw from then were the terrible things she wrote about me on Twitter. Things along the lines of howshe wouldn't have sympathy for me if I died from vaccine side effect complications;

she would mock me for taking PrEP, calling me hypocritical, as one of her conspiracies was that the vaccine contained AIDS (Not even HIV, AIDS. Yes I know). She was beyond out of control, tweeting horrid statements about me and my sister—who she'd also disowned for getting vaccinated. She would say that my sister was never going to be able to have children now because of her choice. She seemed so long gone and we didn't know how to bring her back. We as a family were totally torn apart. We were forced to accept that the woman we'd known as our mother, despite her flaws—a funny, outgoing, popular woman—was gone. She was now a social pariah. Though there was a sense in me that didn't feel like she was totally gone, but maybe that she'd returned. All of the childhood memories I had of her that I'd suppressed in a hope to have a close and healthy relationship with her as an adult, all became vividly clear. They floated to the top of the surface like scum in a bath. During this horrendous time she stopped taking her meds and there were a few occasions in which I saw her in person before being totally estranged, due to familial commitments or such, and in these brief moments I'd look at her face and feel the same fear I felt when I was 8 years old. 'I know this woman' I said to her, 'and I don't like her.' It was very painful. Traumatic. Soon she pretty much turned her back on me altogether, attended rallies and conferences, and made a whole new circle of conspiracy-believing friends. She was having t-shirts printed, and inviting strangers into our family home. She continued to build her following online, with her followers painting her as some sort of martyr for ruining her relationships with her family and friends. Obviously during this time, she and my father remained unvaccinated throughout. He was too scared of her to do it, and so if anyone arguably could've been a martyr, it could've been him, in stupidity, for her love. He frustrated me so much, he stayed too silent

along the way, he was lost, and lacked the necessary skills for confrontation. He stuck his head in the sand and just hoped it would all go away, and heal itself, and in this process he lost his entire friendship circle and family because of her. Sometimes I see him as a victim, and sometimes an enabler— my heart flips between the two. There's no doubt my mum is very mentally unwell. That's why I believe my dad stays around, to support her. He manages to see past the abuse, the control, and the narcissism. For me it's just not that simple. I think there were definitely events in her life and childhood that she never fully healed from, that she went through some trauma, and I think that ultimately festered and grew inside her eventually turning her into who she became today. And it is in this that I can find some compassion for her. Despite the abuse and the neglect, I do feel sorry for her. I pity her. And these feelings are much more painful to sit with than hatred or anger. They're laced with the guilt that's telling you that you should sit and absorb the abuse, take the personal assaults, purely because she's mentally ill. But eventually you have to step away to protect yourself, no matter how painful that may be. I wish the people following her online knew that she is a very unstable woman with a history of mental health issues. She isn't someone to go to for information. She is a broken woman trying desperately to find truth in a broken world that traumatised her early in life. By choosing to believe the government is out to get her, and that public health officials are trying to kill her with a vaccine, she really believes she's taking control, making revolutionary discoveries, and ultimately doing the best thing for her family. In her head she thinks she's fighting the good fight, out of love, so much so that she's willing to lose us all in the process; I think that's the saddest part of all. Trying to rationalise her thought process is one of the most upsetting things I can attempt, and so I try not to do it. You can't

rationalise the irrational: attempting to will send you down a scary path. So I don't see much of my mum anymore. I chose to spend last Christmas by myself, as the online abuse from her leading up to the holidays was so terrible I just couldn't bear to face her. I was being doxxed by her, and had her fans and followers calling me things such as 'depraved' whilst she just sat by and allowed it. I sent her flowers on her birthday, with some chocolates, and a handwritten letter. Not only did she completely ignore this gesture, she went online to proclaim how depressed she'd been on her birthday, and publicly thanked her 'surrogate son' (some conspiracy nut she'd just met) for being there for her on 'such an awful day.' It was spiteful and hurtful. She wants nothing to do with me now, and truly believes in her heart that I am evil. She has said I have lizard blood, according to my dad—that's a new theory she has about me. I'm cold blooded and I sold my soul to become part of the elite. I feel like a ghost in the family now. While my sisters have, for the sake of trying to pretend the family is still normal, sort of chosen to muddle through the trauma, like walking through thick mud. I chose to step away. I feel like I look at my family now and I am on the outside looking in. The ghost of Christmas past. I see all the good things we all once shared, now just a mere memory.

INTERLUDE III

INTERLUDE III

The Key

 I stood in front of his black piano, listening to him singing from a distance in his bathroom across the hall. I reached forward and touched his Grammy award. I didn't pick it up, I'm far too clumsy with such things and would've ended up dropping it. I brushed my fingers along the edge of the piano like some curious main character and I leaned forward to read the writing on his Tony. There were lots of picture frames. Him with other actors I knew. The top of the piano was jam packed with interesting things to look at. Things that made me stop and wonder what I was doing with my own life, and if I'd ever have such a piano top. He wasn't so much older than me, but from his achievements alone he felt far superior in age. I stood back from the piano and caught my breath. I had been excited by him, enamoured almost upon the moment of meeting, but also swept away in the wind of that moment. I was off the ground and was preparing to land very shortly. I hadn't planned to stay over. In fact I was trying to play it cool, and it's the last thing I would've done at that point. We'd seen each other earlier in the week. He'd reached out to me after seeing I was in New York, and with me already knowing him from one of my favourite TV shows, I jumped at the opportunity to meet. He invited me for a drink at a bar in Hell's Kitchen. I was buzzing. Almost surreal in many ways, as I was so used to seeing this man on a loop on this show I watched. I didn't plan to tell him, but equally I wasn't going to lie if he asked. We had great

chemistry upon meeting initially and the couple of drinks at the bar quickly went to 'actually I'm kinda hungry do you wanna grab a bite?' I did, and so we both went with the moment, and found a Mexican place to get dinner. It came out that I'd seen his work. 'Oh god, can't believe you still wanted to see me after watching me in that!' He described his character in the TV show I loved as awful, which was arguably true, but I found it easy to separate the character from the actor. As a Brit I've always found being in New York a genuinely odd experience given the amount of American media we've been saturated with. It's hard to recognise sometimes that you're actually in a real city and not a film set. This becomes even harder when you're sat with an actor you're familiar with from those environments. I legitimately started feeling like a character in a TV show. 'What the fuck are you doing, Sam?' I thought to myself. I was wondering what I was even doing there with him. I started to drink a little to loosen myself up. I was on crazy good behaviour to try and impress this guy, and also to try and act like a normal person that didn't look like he was waiting for the sound of a clapperboard. However that whole night went from one scenic moment to another, and I can't help but wonder if it was me manifesting it, him being plain theatrical, or us just doing normal things that I was just over-romanticising in my head. After the Mexican it was late, and so he suggested we walk over to the Hudson River. We walked a few blocks, then sat down on a bench and talked about his childhood, my childhood, how he got into the arts; we shared stories and traumas, and then soon enough he leant in for a kiss. It was soft and sweet. I lifted my hand up to his cheek, and he put his to the back of my neck. We pulled apart and both giggled, looking back to the river for distraction, New Jersey lit up across the other side. 'Let's do something fun' he said. 'Let's go bowling.' He grabbed my hand and pulled me up, and with a little

jog we got moving down and toward Times Square. Did this actually happen in real life? Were people whisked off after a kiss to go bowling in the middle of the night? In America it seemed so. I honestly felt like Julia Roberts at this point. We semi power-walked, hand in hand, back across to Hell's Kitchen and then down 9th avenue. We marched past any person that recognised him, he showed no interest in anyone but me. That felt special given past experiences I'd had. It was as if only the pair of us existed, bustling down the New York streets at night. Lights illuminating the way, and beaming up his smiling face in reds and blues. We arrived at the bowling alley and paid for a lane. We changed into our silly shoes and got into our booth. The cocktails were flowing, and we took turns throwing bowling balls. We leaned in for a kiss now and then between each ball dropped. We cheered and fist punched the air. Occasionally we would sit back in the booth together; he would put his hand behind my head and finger the hair at the top of my neck. I would lean into it, snaking my head in a backwards motion, and then look towards him and smile. 'Right my turn,' I would say, slapping his knee, leaping from his touch, and grabbing a ball. We had hours of fun, and at the point we'd run out of games, with me winning all the rounds, we decided to head out. 'I'll walk you back to your apartment,' he said. We strolled back, again hand in hand, back up to Hell's Kitchen where I was staying, trying to stretch out the last few moments of time we'd have together that night. Our chemistry had been magical, explosive, and unexpected almost, which was exemplified by us having just spent almost 10 hours together. 'I have an early start tomorrow so I'll kiss you goodnight now,' he said. He was a lot taller than me, and so after I'd climbed a few steps of the stoop to my apartment building, I turned around and met his height. He pulled me into him and we kissed. It was filmic, and quite honestly, didn't feel real. 'Bye Sam,' he smiled and

walked off. I watched him walk away down 52nd Street without looking back. I turned to my building and went upstairs to bed. I was electric that night in bed trying to sleep: It was impossible to switch off. My brain kept replaying all the details of the night, all of its hyper-romantic moments. The lines between fantasy and reality had blurred in a way that evening that I had thoroughly enjoyed.

A few days passed in New York and I was waiting for our next date. It felt inevitable after how well the last one had gone and I probably, in hindsight, put a little too much weight on it. I was basically a tourist on an extended stay in New York, so had little going on to distract me other than leisurely activities. He suggested dinner, and so we arranged a date that suited and booked it in. This dinner didn't feel as exciting as the first date, a little of the buzz had worn off, but that was inevitable. We still had great chats and banter, talking about work, and plans, things like that. We decided to go back to his for a drink. I figured it would be nice to be somewhere more private, were we could probably be a little more intimate with less boundaries. We got back to his and it was a nice pad. I think in terms of New York real estate it was probably a pretty expensive apartment, but it was still relatable. Not so flashy that it knocked me off my feet. He went to make us some drinks and I sat on the sofa in his living room. We'd been drinking for quite some time, and so were both pretty tipsy. After a couple of strong homemade cocktails, we started kissing and fumbling around. Our kissing this time, as opposed to the other night, was pretty ferocious. It had become very physical and I think the sexual tension had been building up for too long already. We grabbed each other, and pulled, and pushed, with our tongues interlocked in each other's mouths. He flung me down onto the couch and thrusted on top of me,

and we kissed like our lives depended on it. We were both lost in the moment and probably kissing for more than an hour, when we started to tire. In a slightly dishevelled state he pulled away from me, sitting upright, whilst I lay on my back on the couch, legs across his, with my clothes strewn and twisted across my body. 'I'd love you to stay but I have to be up super early tomorrow,' he said. I was surprised. I hadn't anticipated having to leave at this time, it being around 2am. I'd assumed with the invite back to his, and our escalating intimacy, that I'd be staying the night. I brought myself up onto my elbows. 'Oh that's fine, I can get a cab uptown,' I said with ease, unaffected. 'I'm sorry, it's just tomorrow I have to fly to LA, and I need to be up and at it first thing.' He apologised again. 'Honestly it's fine. Can I have a glass of water and then I'll be out of your hair.' I said. 'Of course' he disappeared into the kitchen to get a glass. I tucked in my shirt, and ran my fingers through my messy hair. In this quiet and fleeting moment, I felt a sense of disappointment I hadn't addressed yet. I stood up, took the glass of water from his hand, downed it, walked toward the door and put my shoes on. 'I had a nice night,' he said. 'Yes me too,' I reciprocated, opening his front door. He leant in for a kiss. We held the kiss for a moment, then I walked away down his hall, and heard his front door close behind me. I was a little deflated, but thought maybe he had an old-fashioned approach. Maybe this didn't mean anything and I would see him again soon. In my gut I did believe that even if you had an early start, if you wanted someone to stay, you'd accommodate that to satisfy your desires—but I urged myself not to overthink it. I'd played it cool, and that was an achievement. I left his apartment block and went down the street to catch a cab. I was down in Chelsea so had to walk a couple of blocks to get one on an uptown avenue, as I was headed back up to Hell's Kitchen. I got a cab, and on my way

uptown my brain started replaying the evening. It was super late as I watched the blurred lights rush past the window with tired eyes. I put my hands in my pockets to grab my wallet, and felt around for my keys. They weren't there. I double-checked every pocket on me, in a panic. Double-checking, triple checking. Thinking they'd appear in a pocket I'd just checked like some magic trick. The keys were missing. I quickly messaged him. 'Hi, I can't find my keys, are they at your apartment?' He thankfully hadn't fallen asleep yet and replied quite quickly, but he was saying no, he hadn't seen them. 'Can you please look in the living room? In the sofa?' I begged in a panic. I had no way of getting into my apartment, and at 3am I was effectively homeless that night without them. 'No they're not here.' He messaged. 'Omg. I don't know what to do. I can't get into my apartment.' I said. At this point I was legitimately worried because I knew that he was my only lifeline at this time of night. Every friend I had in New York would be asleep now, including the person I was subletting from. I messaged a few people, but no one was online or responding. 'I don't know what to do,' I messaged him again. 'Would you like to come back here?' He offered, I interpreted as begrudgingly. I didn't want to go back there. This fine, romantic balancing act we'd written would go completely out of the window. 'Omg. This is a nightmare. I'm so sorry. Are you sure my keys didn't fall anywhere?' I asked him again. Urging him to look more thoroughly. I'm not the kind of person to lose or misplace things. I just don't. There was no reasonable explanation as to me losing my keys, anywhere other than at his apartment where they may have fallen out of my pocket. 'No there're not here, I've looked. Look you can come back here but we really have to head straight to sleep.' I couldn't stop shaking my head and cursing to myself. I stopped the cab which was still cruising uptown at this point and I asked to get out early. I paid him and jumped out. 'I

have no other choice and nowhere to go. I'm so sorry.' I replied to him. 'It's fine just come back here.' He said. I walked across to a downtown avenue and jumped into another cab. I was mortified. I felt messy and chaotic, an annoyance to him all of a sudden. Rather than an enjoyable fling he'd had the pleasure of spending some time with, I was now a bothersome liability. After a short trip downtown I turned up at his. He opened the door in his boxers. I felt like a teenager arriving home to my dad opening the door in the early hours. 'I'm so sorry,' I said, skulking into his apartment. 'It's fine, lets just go to bed as I have to be up early.' He got into bed in his boxers, and I quickly got undressed and followed suit. I had no idea what to do or what not to do. This wasn't supposed to happen, and now I didn't want him to think I just wanted to have sex, but equally I didn't want him to think I wasn't interested. I got into the bed and waited for any movement from him. He leant over and kissed me, but it felt quite lifeless and the chemistry we'd had over the last two occasions was suddenly absent. And with that, he rolled over, as did I, and we went to sleep.

I awoke to his alarm. He got out of bed quite briskly, and went to the bathroom to have a shower. I was exhausted but forced myself to wake quickly so as to not annoy him anymore. I wanted to get out of his sight as quickly as I could to recover some of my pride I'd diminished from the night before. I got dressed and walked into the living room. I wasn't going to just leave while he was in the shower, so I loitered a little. I perused the things on his piano that I hadn't noticed from the night before. His awards. Pictures with famous friends. My mind wandered. I thought here is a man succeeding, winning, displaying his pride across the top of an instrument he no doubt plays as well. And here I am, a chaotic mess who can't even keep an eye on his house

keys, let alone a dream, and actually making it happen. I felt deflated, downtrodden and embarrassed. I shook my head. I just don't lose things I thought to myself. Whilst in this disbelief I stepped back into the living room and decided to have a quick look myself whilst he was still in the shower. I dug my hands in between the sofa, and lifted up the cushions. I got down on the rug to see if I could see anything on the floor, and there, glistening in the light, poking out from underneath the sofa, were my keys. I froze and slowly blinked for a second. I fucking knew it. I grabbed the keys, and at this point he came out of the shower in a towel. 'They're here. The fucking keys were poking out from under the couch,' I said. 'Oh.' He said. 'Did you not look?' I said, in a tone almost accusatory. I was annoyed. 'Yeah I did. I must've missed them,' he said, walking off into the bedroom, unbothered. I suddenly panicked that in this moment of disbelief, he may have been inferring that I'd pretended to lose them so I could stay the night. I didn't know whether to protest anymore, or just take the keys and get the fuck out. 'I dunno how you missed them last night? They were literally just laying out from under the sofa,' I poked again. 'I honestly didn't see them, I looked.' He said. It wasn't really necessary for me to antagonise any further, I was just upset by what had happened. I left it. 'Ok, well I'm gonna get out of your hair… again!' I said, in jest. 'Sure. Nice to see you.' Something had switched off in him now. There was a cool breeze that had drifted up between us. 'Ok. Apologies again for last night,' I said. 'Honestly it's no worries,' He said. He then leaned in to give me a kiss, and I left his apartment. It was a hot summer morning, so after I left I decided to walk off my hangover back uptown. I felt horrible. The director of this short film I'd lost myself in had said cut, abruptly, had pulled me from the film, and suddenly I was snapped back into the coldness of my truth. I felt like I'd outstayed my welcome, and not just in the literal

way. Our small romantic fling was meant to be transient— I knew that. I just felt so disappointed that after it, he'd been left with his life and I'd been left with mine. I dragged what was left of my pride back home that morning, ignoring the privilege I had of even being in New York in the first place, and only seeing the things I lacked, the ways in which I suffered, seeing them all in every crack I passed on the sidewalk. I felt like nothing after leaving his apartment that morning. I felt like nobody. I wasn't anybody, I didn't have accolades, I didn't have an appointment I needed to get to, or a place I needed to be. I was a nobody. I felt disposable. I was my body. Again. I was someone to be objectified and discarded. I had once been celebrated for my talents, and when the day drew to dusk, I was reduced to my body. The glittering, illusory lights of financial reward in exchange for something I knew I could sell, was too bright a light for an insect like me to ignore. I sold the soul they speak of, for an easy win. A win the equivalent to a game of bowling to the real winners, forgotten about with the passing day. I'm sure he didn't see me as an insect; I'm sure he didn't really see me at all. I have many encounters like this, with a glaring disparity between us. Big star contacts me, sexy boy from internet, to spend some time with. When finished I'm discarded. During our time together I'm silently begging to be noticed, to be reminded that I exist. But they can't hear my cries through the sound of their own desires. This isn't their fault; they can't be blamed for their life or for their partaking in consensual adult relationships. It's my being unfulfilled that is the problem. It's my hunting out excitement in places I know will hurt me. It's in these moments of clarity that the idea of self-love, or the lack thereof, rattles through me. The visceral reality— that I am deeply unhappy, in my choices, in my life—is a hard pill to swallow, only magnified by being confronted by the thriving lives of others. I'd wanted to escape into

this movie romance because it meant I could pretend I wasn't me for a moment. I was the main character in a dreamscape I'd invented. I was happy there. I was fulfilled. I wipe my tears, and shake my head whilst walking up 9th avenue. The credits rolled and the movie ended, and for now, today, finding peace in being unfulfilled is the only satisfying conclusion. The simpler ending. I choose that. We can't all be winners. I go into a donut shop, get three donuts, a caramel iced latte, and try to forget about winners.

A Stranger's Touch

In your arms I'll rest dear stranger,
For you're all I have tonight.
We know no more than what we see,
And more needn't come to light.
It's nothing more than touching you,
A warmth that's free to share.
Our stories aren't important here,
This exchange is only fair.
I'll sleep upon your chest this eve,
In sweet relief we pair.
For we just want a love to keep,
Pretending that we care.
We are just strangers here and now,
In search of an escape.
We know so very little,
But create the perfect shape.
No more will come of this,
Our bodies intertwined.
I love you for this moment,
But we're not the loving kind.

A Stranger's Touch

Gone Again

A fleeting moment graced with his presence. A shooting star in time. Just as quickly as I saw his face, I saw the back of him leaving down my front steps and into an Uber. It never got any easier. As I held myself with my left arm and closed the front door with my right, my heart pushed itself out of my body. I wrap my arms around my torso to hold myself. My breath stutters, my eyes fill with water, and blood rushes an instant headache into my skull. We've rehearsed and performed this goodbye dance so many times yet I never know the moves. My emotions run over me. I feel his presence all over my house, the small touches. His glass of water, my hoodie he wore that afternoon, the dried flowers he cut in the forest and decorated into empty milk bottles that lay upon my kitchen countertop. I cry like I'm grieving when I catch glimpse of the half-eaten carrot cake sat on a plate with 2 spoons that we shared that afternoon. My chest tightens with pangs of fear. The uncertainty of not knowing when I'll feel his familiar touch on mine again. He is good at looking after me, at doing things around the house that my scattered brain finds hard to see. It's out of love, and his actions never go unnoticed. His love around me is a calmness I can only recognise upon his leaving, when the serenity is vacuumed away and I feel a darkness wash into the vacuum of its absence. An anxious blue fills the space until he returns and sweeps it away. I quickly wipe away my tears and get used to the blue. I know the

blue, I recognise it well. It's an echoey silence that rattles through my house. No longer the calming white noise of him filling the dishwasher, having a shower, making tea— but a deafening clang of vibrational, electric noise, resonating through the emptiness of the space. The hustle and bustle of our twosome is stripped back and whittled down to just me. We savour every moment we can while we have them together, until he is gone again.

A Girl Whose Name I Lost

I was sitting next to a boy I didn't know in the middle of the bus. I did try to make conversation but he seemed standoffish and aloof, not taking any of the bait I was offering in the attempt to make a friend. It was a long bus journey to the festival from Berlin, and so I was concerned about how long we'd have to sit in an awkward silence. My instinctive body language had me naturally leaning slightly away from him and into the aisle. I first noticed you sitting in the back seats mingling with everyone on board, being very extroverted. Your eyes kept darting down to me, as I craned my head round, leaning off my seat. You were in my line of sight and we kept catching eyes. It was by accident on my part, I have to admit, though I think it may have been interpreted as flirting. I was envious of how expressive and confident you were. I'm very uncomfortable in social situations, particularly in groups of people I've never met. You kept looking up and over at me. Naturally I smiled when you did, partially because I was enamoured and partially because I wanted to be involved in the bus time frolics. We caught eyes again, you laughed and asked 'what?' I was embarrassed, shook my head and insisted nothing. I became paranoid and kept my head down for the most part after that, hoping that any time I looked up again you wouldn't notice. You were loud and energetic, the life and soul of the 3-hour bus ride. I found you fascinating to watch, like a series of fireworks going off over and over. Running up and down the

aisle, sitting on people's laps, swigging drink that you'd brought on board. After we arrived at the festival I didn't see you for about the first 24 hours, then on the second day on the beach, the sun was beating down and a group of us decided to sunbathe a bit, to cook off our hangover. You sauntered down to us, teeny in a little bikini, your brown curly hair flopping upon your shoulders. 'Hello cute boy who couldn't stop looking at me on the bus,' you said. I laughed. 'Yes, that's me,' I said, not feeling it necessary to explain why I'd been looking. 'Is this space free?' You asked pointing at the empty bank of sand next to my towel. 'Yes it is.' 'Great.' You flung your towel upon it and sat down. You leaned back, closed your eyes with your face toward the sun, then turned to me smiling. 'How are you?' you asked. 'I'm good, just taking it easy today, having some chill time in the sun.' My other friends were to the right of me, talking amongst themselves, and so for a minute it was just us. You asked if I lived in Berlin, I said yes, and you said you did too. You'd moved from Chile to Berlin. 'I don't actually have anywhere to live right now. It's been difficult to find somewhere, so right now I'm just going between friends. Sofa to sofa you know?' I got it, Berlin was hard to find a permanent living solution. Demand often far exceeded supply. 'It's just difficult because I'm an artist and I don't have anywhere to create my art. It makes it impossible. I hope one day I can be settled and just create my art full time.' I felt guilt wash over me when you said that. Made me think about all the things I took for granted. I'd been very fortunate the summer we met, it was a time after years of hustling that I was finally seeing a financial reward, and for the first time in my life had ever felt comfortable. Not just comfortable, but free to create what and when I wanted. You made me acknowledge my privilege in that moment, even if I didn't speak it aloud. 'You're so handsome, can I come live with you? Do you wanna be my daddy?' You

said. I giggled. You laughed also. The extrovert I witnessed on the bus was still here, but now with shimmers of vulnerability. A lot of what you said was in jest, a natural comedian, and so we laughed together, at life, at being an artist, and at mental health in Berlin. You kept commenting on how hot you thought I was. I was too bashful. 'Stop it!' I would say, whilst laughing. We all got up as a group and decided to go in the water, most of us naked, but you stayed in your bikini. We went swimming in the lake, it was refreshing and crisp. It was a utopia of sorts, so many queer folk together in this place. It was a bubble of safety for a weekend. After our dip, we went back to our towels, and you decided to grab your things and head to meet some friends. I hugged you goodbye, and blew you a kiss as you were leaving. I assumed I'd see you over the next few days at the festival, but we seemed to not cross paths again. A couple of months passed and I was at the Cocktail D'Amore party with friends. We went into the garden, and down to the canal to sit and hang. As I walked along the bank I saw your long curly hair. You recognised me before I did you. You were slowly waving and smiling as your body was being held up by the two friends either side of you. You were limp almost like a noodle. Your eyes blinking slowly, and your jaw moving from side to side. I smiled and waved, but just as quick as you acknowledged me, your eyes were closed. I kept walking. This isn't an unusual sight at a party in Berlin, and I was also pretty wasted myself at this point. You had a group of coherent looking friends around you that seemed to be managing the situation. I choose not to take drugs like GHB which normally cause these episodes where you sort of slip in and out of consciousness. My friend asked if I knew you. 'Sort of, we met at Whole Festival once. I don't know her very well though,' I said. I honestly didn't know you well at all. I didn't even get your name. However, in that moment I had a bad feeling in my

gut. Even in my drunken state I could tell that you didn't look well. I remembered the things you'd told me about your situation, and I just hoped they'd improved, but seeing you then, something was telling me they might not have. Berlin is a unique place though. I'd had many healthy and happy friends who I'd witnessed end up in drug overdose situations (as mad as that sounds it's a sort of norm in the queer community, particularly in Berlin) so I tried to not think too much of it. I'm sure you were just having fun, and I was overthinking it. Around a year passed and we were now in the pandemic. I hadn't been in Berlin for a while, and whilst scrolling through Facebook one day I see a friend has shared another person's post. It was a picture of you. 'PLEASE HELP US FIND OUR FRIEND.' You were missing. My heart sank. The post described you, your last whereabouts, and that you hadn't been seen at your friend's apartment for about 4 days. I had no idea what to do, or say. I wasn't even in Berlin at the time. I then looked closer at the post, it was a week old. My heart sunk again. I went to the person's Facebook profile who had shared your picture. The most recently shared post at the top of their profile read something along the lines of 'Thank you to everyone who shared our post and helped in the search for our beautiful friend. Unfortunately she was found and she has sadly passed away. You will be missed so much.'

The air escaped me and I sat in disbelief staring at my phone screen. There was no other information about you, I didn't know any of the people that had posted about you. I reached out to them, and heard nothing back, and none of my friends knew who you were. I assume my messages went into spam, and I didn't feel comfortable continuing to inappropriately pester people who were likely suffering with the trauma of this awful event. I had hoped so deeply in the very brief moments

that we met, that your circumstances had changed. It seems, beauty, we were two ships passing in the night. I just wish, most significantly, I had learned of your name. Besides this, I want you to know that your memory isn't dampened by this absence of information. I'm sorry I couldn't have helped you. Rest well, you sweet angel.

Cherry Blossom

A sweet pink blossom sakura,
Painting skies in April.
And just by May it's fallen,
By June it's just a fable.
We trust that she will come around,
In Spring again, next April.
With precious arms of Cherry,
And blue skies that they will cradle.
You are my cherry blossom,
A spring departure, wondrous rose.
I pray for a reunion,
Where I'll name you in my prose.

ACT IV

Home

I'm currently going through the hellish process of moving house. I've moved house every year now since 2017; sometimes in Berlin there'd be a few apartments in one year. You can't find an apartment in Berlin for love nor money sometimes— the demand far outstrips the supply. Moving never gets easier. In some ways it gets more tiring. I have so much more stuff now. Accumulating plants and ornamental crap is my forte. My heart is screaming and tearing itself out of my chest with every box I'm forced to pack, reluctantly accepting that this house was yet another temporary fix. This house has been my rock, for a moment. It feels so bizarre to put such emotional weight into four brick walls, but this house has provided a structure of safety and security for me, during a time of huge unrest, both in the world and within my own personal orbit.

I remember arriving at the house the day I picked up the keys. I'd flown in from Berlin that morning and was waiting to complete on the purchase, which was meant to happen before noon. My stuff from Germany arrived in a lorry outside the house before I'd completed, the delivery driver started to offload my stuff onto the pavement outside, and I simply sat there and waited for the phone call to say that the house was now mine. This was a staggering moment for me, something I never thought could be achievable for someone like me, who grew up above an off-licence in

Dagenham. I was alone, sitting outside with literally everything I owned in boxes around me on the street. I felt a little sad that I had no one to share it with. It being quite funny, and simultaneously emotional. There was a part of me that found peace in the knowledge that I had earned this on my own and that it only made sense that I began this new chapter by myself. After a couple of hours, and a cappuccino brought out to me by a sweet neighbour who saw my vigil, I got the call, and the estate agent drove round to drop off the keys. She came over, maintaining her distance. 'Congratulations, here are the keys,' she said, passing me an envelope and walking off. It was strangely cold, and anticlimactic, but I waited for her to drive off, so I could have a moment by myself as I pulled the keys out of the envelope. I put the key in the lock, and took a breath in as I stepped into the hallway. I could smell the wood floors, and a dusty emptiness of the Victorian house that now belonged to me. I felt an elation rush through me. I was electric. It was the first time in a while I'd felt such joy. I walked through the house smiling from ear to ear, it was the first time I'd been in there alone without an estate agent chaperone. I was by myself, and it was mine. As this monumental change in my life was happening I was going through so much. A slow motion estrangement in my family. I'd moved countries. All alone. No help from my family, and hardly any congratulations. I had no well wishes from my mother who had recently pushed me away, though my dad had said he was going to come down that day with my sister. He text me moments after I got the keys to say he was on his way down, and had brought my mum with him. I hadn't invited her, but I also didn't say to him that I didn't want her to come. Obviously, I wanted her there—it was a moment I felt such pride over and I wanted that parental validation as we all do, but the circumstances were complicated, and I knew she wasn't going to give me what I wanted. Unfortunately, in that moment the joy left me, and

my guards went up. I immediately went into self-protection mode, and depersonalised to try to prepare for her arrival. My best friend arrived. Jessa. She was late, and moping. She moved slow and had the energy of a sloth on even her most energetic days. Not the ideal friend you want around on the day you get the keys to your first house. We'd been friends for about 15 years, we knew each other very well, and we'd had many laughs throughout the years, but these days things had become tired, and it felt like we were drifting further and further apart, and no matter how much attention I paid to the problem, or how much money I threw at it, flying her out to see me in Berlin on all expenses paid trips, or paying for her dinners, coffees, holidays etc, something had broken, and it was staring back at both of us like our reflections were in a broken mirror. This happened to a couple of my close friendships, particularly after I started making more of a success of myself. I could see in their eyes that they weren't happy for me and it crushed me. Anyway, we suffered on, attempting to revive our friendship, whilst dragging it around like a dead horse. She made lots of derogatory comments about the house upon entering. 'It's so big. I actually feel sick in here. I could not stay in here. It's so scary.' Precisely what you want to hear from your best friend after you've bought and paid for your first house and you're both standing in it on moving day. We had also previously discussed her moving in with me, thinking it could maybe revive our friendship, but from these comments I could tell this wasn't going to happen. She was never transparent, and so I had to take her passive aggressive comments and interpret them the best I could.

My parents arrived at the house shortly after: my mother thrust a potted plant into my hands, said 'here you go. Congratulations,' with a forced smile, and then made her way into the house. It was an orchid, which

was quite symbolic in a way, because I hate them, and you need to be a fucking expert to keep them alive, much like my relationship with her. My dad gave me a housewarming card. I opened it and recognised his handwriting. My dad never ever wrote cards, so I knew my mother didn't want to, and he was trying to save face by doing it himself. They congregated in my new kitchen and I went to the bathroom to escape for a second and ground myself. I tried not to allow the negative energy that had just come into the place to affect how I felt about it. I had worked so hard for this house—I had earned it—and I wasn't going to let them ruin this day for me. I affirmed to myself in the bathroom mirror. My mother had sat herself down with my best friend, and was talking her ear off in a corner of the kitchen. I spoke a little with my dad and sister, talked about the trip over, the completion, and just overall plans for the house. I gave my sister a house tour, and she gave me the little amount of familial validation that I had so yearned for but never got from my parents. By the time we returned downstairs, we found my mother crying in my kitchen. My friend was pacifying her, and I was just annoyed that she was behaving in such a selfish and childish way, on such an important day for me. Thankfully after a little while they all left; my dad had sensed I was reaching my limit and so he rounded everyone up, my mother wiped away her crocodile tears, and they went home. I was pleased for them to go. To be honest, I was exhausted and just wanted to order takeout and sleep on a mattress on the floor of my new house. Over the coming days I saw some other friends who came over to toast the house with a glass of wine or two. Jessa came over again, joining me with Kirsty, another friend of mine, and I ordered us all takeout. The food arrived and Jessa complained about it, picked at it, and behaved in her generally draining way. We spoke about the situation I was dealing with with my mum, how awful the summer had

been losing my relationship with her, and how inappropriate I thought her behaviour was when I'd just got my keys. I had been emotionally distraught by what had happened with my mum during COVID and the girls both knew that. This wasn't the first time I'd confided in them or that tears had been shed. Kirsty spoke about the house being my achievement and that no matter what I should be extremely proud of myself, and she did a little toast. I was grateful for that. We decided we'd all have a go at doing some gardening that weekend because the garden was overgrown like a jungle, as the property had been empty for so long. Both the girls agreed and we were excited for a little project together. After being away in Germany for three years it was really nice to come back and have the opportunity to connect with my friends again, to hopefully rebuild and strengthen our relationships—which I thought we were all excited for. When that evening ended and as the girls were leaving, Jessa helped herself to all the leftover takeout that had been put in the fridge, filled her bag and took it with her. Kirsty gave me a side eye that suggested what we both were thinking and thanked me for the dinner. I waved them goodnight from the front door, and said I'd see them in a couple of days. The following day I get a text from my dad that stopped me in my tracks. My parents had a holiday home in Spain that they often went to in the summer. The text message read 'Just so you know, your mum is going down to Spain tomorrow, and Jessa is going with her. She's booked her a ticket. Don't get involved or tell her not to go, otherwise it'll all come crashing down on you'. My legs started shaking, and I reached for a chair in the empty living room I was standing in and sat down. What? A million thoughts started rushing through my head, and I couldn't focus from the red mist that appeared before me. I text Jessa immediately 'are you going on holiday with my mum tomorrow?' 'Yes,' she replied. 'I

don't even know what to say' I said. 'I knew you'd probably have an issue which is why I didn't tell you, but I really need a holiday and to get out of London, and your mum was offering so I said yes.' I had no words. My so-called best friend had arranged to go on holiday with the mother who had estranged me, 4 days after I moved back to the country after living abroad for years, all behind my back. She had also lied to me and Kirsty, saying she would come gardening with us that weekend knowing she had flights booked to Spain with my mum. I had sat and cried to her, for months, about the on-going situation with my mum. I was bereft in losing my relationship with my mother, and I'd told her every detail, and somehow in her world she thought it would be appropriate to book a holiday with her because she needed a break from London. This betrayal was unlike anything I've ever felt before. I was obviously livid at my mother for her involvement in this. She knew this would hurt me. She knew that Jessa was an easy target to be bribed with a free holiday, and brainwashed by her conspiracy beliefs. But for my best friend to sell me out for a free trip to Spain, to put all the pain I'd confided in her to the back of her mind for her own selfish needs? It showed me what she thought I was worth, and it was at that moment she became no longer my friend. I was in grief. My sisters were in shock, my other friends were in awe, even my dad was shocked but he wanted to protect me from any further aggravation by warning me this was happening, otherwise I never would've known. I guess I would've found out from the holiday pics. This was the first week in my house. The house I'd dreamt about and worked my little gay butt off for. It felt tarnished in a way. I desperately tried to protect it from being so, but I couldn't help the painful loneliness, disappointment, and betrayal that consumed me shortly after. I missed all my friends in Berlin, my boyfriend lived in France, and now my relationship with not

only my mother was non-existent, but I'd now also lost my best friend. I worked hard over the next months to make the house work for me. I made it a home. I filled it with as much love as I could fill it with. But houses are supposed to also be filled with love from others. No man is an island, and my love alone just couldn't fill it's halls. So I made the decision after about a year, to move to somewhere smaller. I cried a lot with every box I filled and taped. A year had passed in that beautiful house, my relationship with my mother was a thing of the past, and I never spoke to my best friend again. I cried so much for what that house never became for me. As I filled up the moving van, and saw the 'house of my dreams' gutted and emptied, I wiped away my tears and counted my blessings. Dreams are sometimes just that.

Things I Do

I needed to get out of the house. My brain was feeling unstimulated and my mind was driving me nuts. So I went into central to go to an exhibit. The Tracey Emin / Edward Munch exhibit at the Royal Academy. Tracey Emin is one of my favourite artists. I became obsessed with her after reading her autobiography, which I would describe as one big open wound—which is also how I like to write myself. It was refreshing how brutally honest she was in an age which is all about constructed and carefully curated appearances. This particular exhibition was named The Loneliness Of The Soul, which seemed appropriate for my current state of mind. It had been a dark few months, and I need to figure some things out. I walked into the space and felt quite overwhelmed. The large canvasses with paint splashed across the surface like bodily fluids, the nude bodies with a desperate longing for belonging. It resonated. I started to feel myself welling up. My eyes filled slightly and I quickly stopped the tears from forming. Crying in a gallery over art? How cliché. These two artists lived 100 years apart, and yet the work existed in the same space, with the same message. One of palpable loneliness, and with a desperate search for meaning. A scary feeling rushed over me, one of disappointment in the world. One of hollowness. 'Why does anything matter?' Yet at the same time I felt visited by inspiration. A century separated these artists, connected in the familiarity of their works, and a haunting feeling of

solitude in their mortality together as artists — both hanging in a silent gallery. A sombre message left behind, but a message nonetheless. Not just a person-sized gap left after your DNA has perished into the ground to fertilise the otherwise barren soil. I stood in front of a neon sign: 'More Solitude.' Seemed ironic as I'd come to the gallery by myself, to escape feeling alone at home. I felt my throat. It was a little sore. I'd waited on my knees in a hooded mask last night, taking men's dicks in my mouth again. It's my vice: I find strangers online that are willing to come and use my mouth anonymously. I don't see them, I just feel their soft dick land onto my tongue. It's usually cold, the feeling of the foreskin. Then I usually slide my tongue inside, exploring the dick head, feeling the dick grow inside my mouth. This is usually the most exciting part of the endeavour. Its is a drug. My masked face with just my orifice exposed, meeting their masked area, exposed to only them, but gently dipping into me. Blinded, my senses are overwhelmed and I am desperate for their cum. They unload into my mouth, and then they zip up and leave. No talking. I'm just used for a few minutes. I'm using myself ultimately, for the pleasure and thrill. It's the allure of the forbidden. The taboo. I feel a little shame about it. I wonder how many others like me do the same. I wonder why I have this need to be used like this, and why I find it so extremely satisfying. I walk past men on the street and think of my mouth meeting their groin. I'm a deviant. Still, my vision masked, them simply entering into my mouth for the pleasures of taste and touch. My kink for it deepens and grows. Why do I like to disappear so much into this act? I stand in the gallery taking in the pieces. In one large pink painting with scrawled text Emin talks about her broken vagina—her youth taken from her too soon. My asshole has been broken for a while, a therapist I once had suggested he thought it was psychosomatic. I used to allow men

to come into my house with the door open and fuck me without seeing them, blindfolded. Waiting on all fours. They would come in, fuck me, ejaculate inside me, then leave. Sometimes this would be multiple men in a day. My therapist seems to think I was so depressed I was fucking my body— killing my body— in a self-harm of sorts. My body was retaliating to my self-destructive behaviour and closing up shop. Not allowing anyone else in, so causing me pain when they tried. I'm not sure it's as simple as that, but I do think there was an element of truth to it for a moment. I do wonder how sex positive I really am about multiple strangers fucking me over and over, dumping their load into me until I feel like a used, worn cum rag, my anus is swollen and slightly prolapsing, and then likely having to go on antibiotics a week after because of it. I'm not sure, but the freedom to do it and wonder is a freedom I don't take for granted. These pieces hanging on the gallery wall haunt me somewhat. I start to tear up again. Stop it, Sam. I'm pretty fragile these days. On a knife's edge. One small thing can tip me over. All this shit with my mum has fucked me up. I've always been pretty fucked up by her, but recently it was impressive fuckery. I was always pretty nervous and fearful of her, whilst also adoring her in many ways. It was a tense, constant dichotomy. I don't really remember much about my feelings as a child. Maybe there is a reason for this. I remember things, places, events, people… but I don't really remember feelings so much. I wonder if I have forgotten the feelings through choice. I find it hard to pinpoint what I liked and didn't like. What made me happy and unhappy etc. I still have that problem now, which makes it harder looking back and trying to figure things out in hindsight. I had a very close relationship with my grandmother. She was the loving Nan everyone would've wanted. She was big, voluptuous. I remember her huge breasts and belly were the perfect resting place for a small child.

Her soft skin and the smell of lavender. Lying on her felt like a big plush beanbag, that radiated love and comfort. I would lay upon her chest and play with her necklace and earrings. I can still see the symbol now: the gold intertwined arms, forming the almost heart-like shape of an Orkney Celtic symbol, made by a Scottish designer. My nan was from the Orkney Islands and had a soft Scottish accent. She would sing little diddies that used to make me fall about laughing. We laughed a lot together. She would make me 'mince and tatties' for dinner while I played Lego on the floor. I felt safe and calm. One night I stayed at her house. I remember waking up in middle of the night, lifting my head off the pillow and seeing a bird on the inside of the windowsill. I started screaming. 'NANNY, NANNY THERE'S A BIRD!' I was terrified. My Nan woke up and stumbled into my room. As she walked toward the window her face creased and she hunched over on her knees, crying with laughter. She picked it up. It was a Christmas tree decoration of a robin redbreast. She sat on my bed and we cried together laughing. I was probably about 7. She was my best friend, I think, at that point of my life. My trusted confidant, my pal, my Nan. We loved each other a lot, and bonded in a way that was manifestly evident to me as a young gay boy.

My mother had a less similar upbringing to her. It was complicated. She was a single mother raising four children without a father in the 1950s. She'd initially been pretty displaced being called down to war from the Orkney Islands. She joined the Women's Auxiliary Ferrying Squadron or the WAFS, as she called it. She married a man who had an affair, left her, and found herself pretty much destitute with three kids. She ended up in a mental institution when she was pregnant with my mother, as the man who had impregnated her, a different father, fled

when he found out she was pregnant. It was brutal, and I guess all this trauma added up to create a less than ideal situation for my mother to be raised in. That being said, it was difficult for me to process these facts as a child— my grandmother was perfect in my eyes. My mum would often remind me that she wasn't the woman I thought she was, which was very hard for me. It gave me this sense of distrust, for the both of them. She was the woman I loved the most, and I was being told she wasn't to be trusted. My grandmother died when I was 20, and in some ways I'm glad I never had to relearn who she was as an adult, like we have to with our parents. She's been frozen in time for me, and I only look back at her now with love and fondness, and compassion.

Dear Nanny

Sometimes I wish I could turn up to your maisonette. I'd ring the plastic white doorbell, and see your large silhouette through the mottled glass move slowly towards the door. 'I need a friend for a couple of days. I'm sad, Nanny,' I'd say. 'Oh don't be silly. Come in and I'll make us a cuppa tea. A few sugars. Nice 'n' sweet,' you'd reply, pulling me in for a cuddle, and ushering me to the floral sofa. The place would smell of lavender and home. I'd see your crosswords laid upon your little table, all your knick-knacks on your shelves, and Catchphrase would be on the TV. We were so good at that, a race to see who could guess the picture first. 'Fancy mince 'n' tatties?' You ask. God my face would light up at the idea. 'Listen I'll mash it all up 'n' you won't even know the carrots are in there,' you'd say. I was never a big fan of my vegetables. 'I'm fine with the carrots now, Nan, don't need to mash them in,' I'd say. I'd sit with you and just tell you I'm sad. I'm sad, and that I've missed you. You'd make me laugh about something and then I'd wind you up. We'd be giggling together. I'd say something funny about all the cake crumbs you were dropping down your front. 'Saving those for later?' I'd tease, and you'd throw your head back, with your hand on your chest trying to catch your breath between laughs. 'Wanna play Old Maid?' You'd say. 'Yes!' To do something so simple would be a joy, with you. I'd tell you about all the recent years of my life while we played. Catch you up on everything that's happened. The lilt in your

Scottish accent would calm and comfort me. I'd cry and say I missed you. I do miss you. It's been 15 years, Nanny, and I still need you. Thank you for being my best friend for 20 years, before you had to go. I love you. Sammy Xx

My Dad Downstairs

I'm upstairs in my bedroom taking pictures of my throbbing dick for Twitter which I've frantically jerked to fill with blood for the most alluring picture. I jerk off and then contort my back to take pictures of my ass, twisting my lower spine until my upper glute reaches that perfectly plump, ice-cream-scoop level of roundness. My iPhone is leaning upon the window, and I press the self timer, taking around 30 shots hoping there will be a couple good enough to post online. I do this so that people remember I'm selling sex, they subscribe to my website, and I can continue to pay my mortgage.

All this is happening whilst my father sits downstairs on my sofa watching the golf. Currently, he is a refugee under my roof after my mother tried to murder him last night. 'Morning, would you like a coffee?' I say to my dad while he sits on my sofa like my teenage son. It's a very weird power dynamic shift in my life: having to give my dad a roof over his head to escape the chaos in his life. I hand him a coffee. 'How are you feeling?' I ask, in full knowledge that my dad will not fully disclose this. He talks in rhymes and riddles like most fathers. Never really addressing feelings. They just don't like sharing, from either side. They are the "Don't Ask, Don't Tell" generation of men. He's been going along with things for the last year, clinging onto his marriage desperately—a bracing, white-knuckle ride. It's sad to

watch. My mother's radicalisation is a disturbia we as a family have all just had to adjust to as a new normal of sorts. He has been struggling to hold it together at times. When his 'doing the bare minimum and hoping everything will blow over' game plan doesn't work for the more aggressive scenarios, he doesn't know what to do. It's been frustrating and disappointing at times. As the only son, and eldest of four, I've found it very infuriating seeing him do so little to stop my mothers manic train crash. He stuck his head in the sand, and upon lifting it out realised nobody was left. Nobody but him, her, and wasteland. I begged him to do something, after her initial concerning Facebook postings overstepped a line. I would ask him to put a stop to it as her husband, to protect our family. Take her phone away, I pleaded. To which he would respond that he didn't have Facebook, so he didn't see it. 'Just ignore it,' he would say. His excuse was out of sight out of mind. Until the real life consequences of her actions, her outbursts and behaviours started falling from the sky around him like the crushing fragments of a distant volcanic eruption, and he could no longer ignore it. He didn't realise he was in Pompeii until the fires were already raging— that or he was in denial. Last night I got a call at 2am: 'Dad calling'. I immediately assumed somebody had died. I didn't have much, if any, contact with my mum so the first thing I imagined was that something had happened to her. 'Sam, there's been an altercation. I need to come to yours and stay for a few days.' Luckily, I was up late that night or I would've missed the call. No one had died, I breathed a sigh of relief, and, with my next in breath, I felt anxiety rush through my veins like an electric current. 'What's happened?' I asked him. 'I'll let you know when I'm with you. With the police right now so can't really talk.' I rub my face in despair. I force myself awake, barely holding my eyes open. He turns up at my house at around 4am. I open the door and see him

exhausted and defeated. I let him in and made him a cup of coffee. He puts his bags down, just a few things with basics, underwear, toothbrush, phone charger. He perches on the edge of my sofa, with me on the edge of the dining table, and after a big sigh, and a slow shake of the head, he begins to explain. He tells me that my mother had punched him around the head multiple times because she'd found a face mask in his work bag. He believes she placed it there herself, because he doesn't recall one being in there. She was belligerent drunk, and her anti-vax / anti-covid beliefs had become so extreme by this point, him being caught with a face mask was seen as an ultimate betrayal. He kept telling her to hit him again. 'Hit me again I told her,' he explained to me. She punched him repeatedly. Until he threw her off him. She flew across the kitchen, slamming into the oven, and in this moment she reached for the kitchen drawer, pulled out a carving knife and pointed it toward my dad. He told me that he knew there wasn't a sharp knife amongst their kitchen collection: 'all our knives are blunt as fuck, so I grabbed the blade,' he said. He held the blade while telling her 'go on then, do it'. 'She screamed bloody murder, then said she was going to call the police,' he said, which he then encouraged her to do. Knowing that she was nuts and the police would quickly find this out. She called the police, lying about the series of events to favour her in the scenario, painting a picture of a vulnerable woman in distress. The police showed up. They were taken into separate rooms, in which my dad helplessly explained what had happened, showing my mothers Twitter page. He explained that her views had gotten out of control, and she was uncontrollable and unhinged. Meanwhile, my mother was in another part of the house, not doing herself any favours by preaching about conspiracies to the other cop. The police decided to separate them for the night, but as my dad didn't want to press charges, they held off

from arresting my mother — although they said it was a narrow escape for her. She should've been sectioned— everyone's best interest, but the police officer said she would have had a greater chance of being sectioned if an ambulance was called in from her attempting to harm herself. The police said they didn't have many powers when it came to sectioning, and I have no doubt that my mother's manipulative and charismatic behaviour would've been her get out of jail free card; for both the possibility of being sectioned and being arrested for attempted murder. My father was told he had to find alternative accommodation that night, and wasn't allowed to stay in his house. He searched for a hotel nearby, but as it was already so late in the middle of the night he was unable to find anywhere. Hence him calling me. I have no doubt this must have been a very difficult call for him. His pride felt very much swallowed when he arrived at mine, and almost immediately I desperately attempted to disassociate myself from the situation. Seeing my father in such a helpless state, induced by my mother, was way too upsetting, otherwise. I sipped coffee with him on the sofa. He mentioned that the social services were now involved, as my sister was still only 17. A minor living in a violent household. It is beyond unfathomable that we have reached this level of disturbance within our four family walls. A madness crept in and turned our entire lives upside down and it's truly devastating. I was certain I would stay strong, and needed to, to pay the mortgage that was supporting the fallout from this chaos. It was so difficult to keep a sense of normality, but I didn't have a choice; I had bills, and unfortunately for me, it was being sexy 24/7 that paid my mortgage. No matter rain or shine, I would still be arching that back, with a camera on a tripod. I laughed with friends about the madness of pretending to be sexy in such a horrendous time in my personal life, just so I can keep a roof above mine and my father's

head. My dad is downstairs stifling tears into his coffee, contemplating walking away from his 35-year marriage after almost being stabbed, while I'm upstairs pouting and taking hole pics. This is 2021.

Floating

I've lost my spark. I've been feeling like my lights have been out for a while. I've been functioning, getting on with life, having a laugh with friends, getting on with work, but with a sense of emptiness in my heart. My flame went out. It's like I only just realised I've lost passion in all the things I used to love, and I'm now coming to terms with the fact that my fire is gone. I gained so much in the last year, but also lost a lot. After my mother estranged herself from me and my sister, it took a lot of processing. I never thought she could be capable of such behaviour, but in the last year I've seen a side to her that has deeply upset me, and given me a depth of trauma to which I'm not familiar. I've had to almost create an alternate reality to live in as a way of escaping it. The pandemic hasn't just been awful in the obvious ways—it's also birthed a misinformation era of seismic proportions, and created a time of great conspiracy; a time to which we are all bound, divided by, and in which relationships have been ripped apart. I posted about having the vaccine onto my social media. I have a lot of followers and felt, especially with everything I was experiencing in private, it was my duty and responsibility to share that I was choosing to have it to protect myself and others. I was also happy to have it, and ready to get my life back. At 8am the next day I had a call from my angry father telling me that I had destroyed the family, and that I was an idiot for posting it online. That everything was going to tumble down around me and

it would all be my fault. My mother is insane. Literally. Though in her reality she thinks she's the sanest of us all. 'Why can't you meet her in the middle,' people say. 'Can't you agree to disagree?' That would be assuming that she is functioning on a normal rational level. Would you tell someone they should just agree to disagree with someone in The Manson Family? 'You can believe in what you want to believe in, but I don't choose to believe in that' I say to her about her anti-vax, anti-mask, covid conspiracy nonsense. 'IT'S NOT A BELIEF, IT'S A FACT,' she screams at me, exasperated, with rage in her eyes. I am not human according to her new beliefs: I am a blue-blooded lizard is what the conspiracy scriptures say. A lot of the elite are. There is one particular TV newsreader who has quite a prominent jaw, but my mother believes she has gills—because she's part fish. She says this all straight faced, all-knowing. Where do you 'meet you in the middle' with this? Now most of these things are so crazy you'd imagine they'd get someone committed, but no. It's impossible. For one to be sectioned in the UK you have to attempt to take your own life, and fail. There's been many times in the last year I've wanted to march her off to a facility. Then you look at marches happening in London with hundreds of thousands like her, believing in these totally insane things, and you think, they can't all be mentally ill. It's a cult, a cult that is moving beneath the surface of our daily lives that nobody can see. There isn't a commune, or a big tent, or a gated-off house, it's happening all around us, in private messages and online forums. People are being radicalised from their own armchair, in their living room, in front of their family. That makes it scarier. Many days I question where she is. Is she very mentally unwell, or is she just a fucking cunt. I ask myself. I flip between the two depending on my mood, and how I'm dealing with everything. Only a few weeks ago we had police and social services involved, because of a violent altercation

caused by her beliefs —the very beliefs that people suggest I should meet her halfway on. It's been a brutal year, unexpected and sobering. I've resigned to feeling like I no longer have a mother, which is how I get through most days, but it makes living life difficult. The smallest thing can tip me over, sending me into floods of tears. Then the rest of the time it's nothing. Like the fierce concentration of a tightrope walker. That's my everyday reality: just concentrating on keeping everything together. But it has made me lose my sparkle. My drive is gone. I just float now, suspended above the abyss.

A Big Brother

I woke up to that rhythmic vibration of my phone ringing. The buzzing wove its way through the floor where it lay, up through my bed and into my bones. I roll over and see the familiar, but somewhat haunting 'Dad calling'. It can wait. I was tired, and comfy. I rolled over and went back to sleep. As quickly as I shut my eyes, the vibrations started again. I sighed. I rolled over, saw 'Dad calling' again, and now felt a pang of fear. I leant down, grabbed my phone and answered. 'Hello,' I said in a groggy morning voice. 'Hi. You alright?' He said. 'I just woke up. What's up? Who's died?' I said. That was something my dad and I always used to say in jest when either one called out of the blue. 'Ok. No one. Well, yes, everyone is still alive. But. I'm calling to say that your mum took an overdose last night and went into hospital.' I was hanging over the side of the bed, and I rolled onto my back. My eyes half closed. My breathing heavier, and my heart sunk to the back of my chest. I also admittedly felt no real surprise given the circumstances, this call had been coming for a while. 'She went into hospital because she apparently took 45mg of diazepam with two bottles of wine. She wasn't in a coma or anything, she was sat upright in bed, drowsy. I called the NHS111 line and they sent an ambulance. The paramedics decided to take her in because she wasn't of sane mind, and they needed to observe her and do some tests,' my dad explained. I was lying in bed half asleep wondering whose life this was because it certainly

didn't feel like mine. 'Anyway. she went in and then after a few hours her bloods came back normal, and she was discharged by the psychiatrist as being all well and good. I couldn't believe it, I said are you fucking kidding me?... they basically said she was my responsibility now,' he said to me. 'When we got in the car I turned to her and said 'you selfish fucking cunt'.

It's weird hearing your dad talk about your mum in that way, but in this circumstance I agreed with him and felt relief that he felt the same way as I did for once. I'm not even sure at this point if she even took the overdose or just pretended. Her bloods came back normal and she was discharged. So they obviously deemed her as fit and well enough to go back home. Though even if she'd pretended, surely that's a sign of enough mental instability to get somebody properly evaluated. Anyway, my dad took her home and to bed. He told me on the phone that I needed to let my little sister know. She'd been staying with me for a couple of days, for the first time in months. My mother had waited for her to be with me to do it, I knew it. It was almost like a punishment. I laid in bed wondering how the hell I was going to tell her. I got up and made tea, and breakfast. Filled a tray with cereal and cakes. 'Morning.' I walked into my lounge where she'd been sleeping on my sofa. She sat up: 'You always do the best breakfasts!' she said. I sat down and poured us some cereal. I acted pretty normal for the most part, popped on the TV and waited for my sister to have a bite to eat before I dropped this news on her. After we had a few sips of tea I said 'So, dad just called. I have to tell you something which isn't very nice.' I could tell she was bracing herself for something unpleasant, but had also immediately put her guards up to protect herself. I've known this girl since she was a baby. I held in my arms and rocked to sleep, her

facial expressions were all too familiar, and no matter how hard she tried to conceal to me how she was feeling, I would always know. I told her nonchalantly over a mouthful of cereal that our mum had just tried to commit suicide and failed. It was bewildering and didn't feel very real in the moment. It felt very matter of fact, like I was telling her a story about someone else's mum. We both seemed pretty disassociated already from the situation, like we were both already prepared for this. She sort of shrugged, glassy-eyed. I recognised myself in her when I was the same age. Depersonalised to cope. I could tell her heart was breaking with this news, but she wouldn't let the pain reach her face. She had a strong head on her shoulders. We're so used to this manipulation and abuse. Sixteen years between us as siblings—a huge generational gap that seemed for a second much smaller—in a shared experience that seemed almost ordinary.

~~Love~~

If my mother, who is meant to love me more than anyone on the planet, can cut me out with such reckless abandon, then how is it possible for anyone else to love me. If my best friend of 15 years can knowingly betray me in such a way with such disregard for my feelings, then how is it possible for somebody else to love me. These are thoughts that run through my mind often. In the last year I have found myself unloveable. I lost my belief in love. The darkness has ricocheted through my life, and fragments have fallen all around, damaging my relationship with my partner of 3 years in the process. Not only have I misunderstood what love is meant to mean, I've also found my interpretation of love to be lost in translation. I am blocked. Nothing coming in and nothing going out. My body is a vessel for others to prowl over online, and because of that I have depersonalised and dissociated with my physical self to such a level just to be able to cope. Since these estrangements in my personal life I have found myself, alongside my professional self, as disposable, both in life and love. Somebody that people use and toss out, like trash once they're done. It has been brutal. Difficult to process and sometimes crippling. If your own mother can put her opinions and beliefs before her relationship with her only son, then how am I supposed to believe that anyone else could put me first. My boyfriend implores that I listen when he tell me he loves me. He lists all the things he loves about me.

I sit there like a cold and vacant shield. Bewildered by his love, with each of his words glancing off me and falling to the ground with a clang. A small voice shrieks inside my gut to listen. 'Listen to him and allow him to love you,' it yells; 'you do deserve love.' My mind shrugs this away, and my heart dangles in a hollow and cavernous chamber of nothingness rattling inside me like a car trying to start in a snowstorm. I know that I need to find forgiveness and compassion to heal my heart. My mother is ill, and her beliefs are beyond rational, simple-minded delusions, and reminding myself of this gives me an aspect of peace. 'She knows not what she does,' I tell myself, but any rational words slip off me like Teflon. I feel frustration and anger. I feel hatred for my friend for engaging in my mother's madness, encouraging it, and betraying and abandoning me in the process. I feel sick when I think about the betrayal, it eats me up. I feel such disdain and shame for my mother when I see her posts online and her new extremist points of view. Each one of her vile opinions penetrates my skin like a splinter, piercing and embedding into me every time. My body does not reject them so easily. Someone so liberal, swept up and taken, gone with the wind of modern day misinformation and extremism. 'Fake news. A term invented by the right to assail the left, whilst spreading the exact thing they invented to criticise. Fake news ruined my real life. My mother's brain has rotted like a sweet-tooth, and it has decayed everything in its wake. COVID, or vaccines, or the plethora of other things questioned in this diabolical movement, are not just curious beliefs: they are indoctrination bait, hanging on a fishing line, dangling in the waters of the vulnerable, luring them into this cult. Let me be clear when I say that it is just precisely that, a cult. Those who are 'awake' and connected by this movement online, are encouraged to disconnect with family members, stand up to the police, and to not believe or trust medical professionals

/ scientists / intellectuals / artists. It is targeted at the vulnerable, or the spiritually curious, by promising them that most historically-charged, hot-ticket word: 'freedom'. It isn't just about being anti-vax. These people are leaving their families and planning to start communes, and all the while this happens the world keeps turning, the damage of this misinformation culture continuing to burn and spread like an untreated infection through communities, friendships, and families— all across the globe. Before COVID-19, I had a family, with friends that I loved, and although the disease didn't take them, the opportunists that monetised fear and human scepticism, did. Some of the highest engagement on the internet is generated from conspiracy theories. People cannot get enough. High engagement equals high revenue. Human beings are fascinated by the unknown, and it's very easy to manipulate this for personal gain, and particularly for evil. When people are at their most vulnerable, they are even more susceptible to predators. Predators prey upon the gullible, and monetise it. The likes of Donald Trump and Nigel Farage monetised fear, and caused political shockwaves that will be felt for generations all because they knew how to prey upon confused and naive people in support of their own greed and narcissism. Bit by bit, these things fell into place over the last few years, creating the perfect landscape for somebody who is mentally unwell to lose all hope and therefore seek out hidden answers from the world in which they live. The 'question' makers were the ones who held the 'answers'— it was designed that way. The general public, or victims of this horrific plan, took every puzzle piece fed to them by algorithms and lost their minds. What started as vilifying institutions like the EU by spreading misinformation via data misuses from the likes of Cambridge Analytica, evolved into the algorithm driving absurdities such as Lady Gaga injecting herself with baby blood (or 'adrenochrome'

as it's known in the movement) in quest of eternal youth. You'll find that it's almost never anyone famously right wing accused of these barbaric and nonsensical things, it's usually prominent left wing figures and/or famous humanitarians. Watching the radicalisation of my mother happen in slow motion over the past 2 years has given me an insight into how Nazi Germany came to bring such terror across the world. It is not hyperbole to say that I am terrified. Scared of what has happened to my mother, scared at what has happened in politics, and scared for my future. So now, as the world begins to take shape again in a post-pandemic world, though unreligious, I pray, in my own way, that my mother will be freed from this nightmare. That she will see light in the world she inhabits again, and she will break out of the hopeless hell she has created for herself, and all of us around her. I pray that she will believe in love again, and look, like Lot's wife, back over her shoulder and see what she has lost. I want her to love me again, so I can learn to love again, myself. Because when all the anger, resentment, confusion, and frustration settles, all I'm left with is sadness. Loss and sadness, and the overwhelming fact that I've lost my mother, and that I miss her. I miss her. I miss her so much. I want these opportunists to give up, tell the truth, and let these people go. They should be demonetised and deplatformed, but unfortunately these narcissists are government-deep. They are the villains, and I hope history will hold them accountable. In this hopeless and bewildering modern era of propaganda proliferating across social media—generating casualties like a nail bomb—I pray for change, I pray for hope, I pray for the good guys, I pray for the superheroes, I pray that all those trapped in dark will see light again, and ultimately, I pray for love to prosper again, and for my mother to come back to me.

INTELUDE IV

Dirty Jeans

Same jeans. Unbuttoned. Day old underwear.

White top. Out of bed, just. Three coffees in.

The caffeine chauffeuring the anxiety down and through my limbs.

A plague, a depression. Worries and priorities.

Regardless, I take a back seat.

Another brown letter lands through the door, and I'm reminded of the system I cannot escape.

What is more important? Your next meal, or next hug? How do we remind ourselves we exist?

You put your arms around me and I felt alive. I could smell you. You were real.

For just a second I existed. Then I, and you, disappeared again.

Locked

Something feels locked in my throat. You know the lump you get in your throat when you're about to cry. That's what I've got, but it won't go away. Apparently the 'lump' is actually the feeling of opposing muscles in your throat acting upon the glottis (or the opening between your vocal chords), working against each other. The globus sensation. When you're stressed you need more oxygen, right? So we start breathing quicker and then the glottis expands to let all that extra air in. The only issue is, stressful situations also make us swallow or hold our breath, to stop ourselves from crying or, I guess, saying what's on our mind. Those two separate things require closing the glottis and cause the muscles in our throat to constrict. As different muscles are trying to open and close the glottis at the same time, the effect is a sensation similar to that of swallowing an egg. To be honest, it's no surprise this came about. I've been crying on and off for the past week about all the things consuming me. My boyfriend visiting from France for the first time in 3 months because of COVID restrictions, and me basically being traumatised from months of hell. I'm frozen like a block of ice after not seeing him for so long, and I am finding it hard to give him even a slither of affection, making me feel immense guilt and sadness. Seeing his disappointment in my distance from him is enough to make me want to jump off a bridge. The guilt has sat lodged in my throat like a 2 pence coin. I try to swallow it away, cough it up, but it's sat there.

My boyfriend is a good man. Too good for me probably. He does all the things he can to make life easier for me, especially as he knows I'm going through a tough time. He cleans and organises my apartment, makes me lavish breakfasts of french crêpes and pain perdu. He even does my laundry in a timely fashion, unlike me who waits for it to start spilling out of the laundry bag and crawling across the floor from the corner of my bedroom. I don't have any love to give these days. I feel like a shell of myself, full of darkness and dust. I don't know what love really means, and I feel such distrust for people. My barriers have come fully up, and I'm shielded from feeling anything, at all. I am independent, I've always had to be independent, and the events of the last year have only reminded myself of that. I'm too scared to let him go and be alone though, so I cling on, while pushing him away, hoping that the wind will change and I'll learn how to love him, and myself, again.

Kink

My habit for anonymous sex is back. An addiction rearing its ugly head again. It's been a while since I'd been on my better behaviour. Since I moved house, in the heart of the lion's den in East London, it has been harder to avoid and ignore the urges and temptations. The devil makes work for idle hands, and the last few months I had been terribly idle with nothing but my thoughts to consume me. I'd spent the whole of Christmas and New Years alone, then on New Year's Day I tested positive for COVID19 so spent another 10 days locked indoors by myself. During this time. I actually had a full mental breakdown: like an on-the-floor-pulling-my-own-hair-out-screaming-crying-style breakdown. It was a burnout, that was brought on from not being able to go anywhere and only being confronted by my own thoughts. When I broke free from this I was animalistic, like a feral animal locked in a cage and then consequently let loose. I wanted any and every dick I could get my hands on. I wanted to physically smell them, taste them, and milk them. There wasn't enough in the world to please me at this stage, and my blood pumped through my body like a raging bull on the hunt to find them. I would wear a hood, wait on my knees, leave the door open and let guy after guy come in and dump his load into my mouth or ass. Day after day. A hyperfixation. The line between kink and unhealthy addiction blurred. They often do. Is it a kink or are you just fucked up? I often ask myself. When I get into this horned up state

I would basically just let anyone with a penis come into my home and enter me. My standards were very very low in these moments. I wanted to be used. Attractiveness doesn't even come into it because it's not really relevant to the kink. I wanted the thrill of danger, the fear of the unknown, the buzz of the taboo. This adrenaline rush reminded me, for a moment, that I existed. One night, I had three men arrive at once, stand above me, and each put their dick in my mouth one by one. One of the men was particularly forceful and smashed his dick into the back of my throat and I felt something pop. They all took turns, making me suck them, then they stood around me and jerked off. One said he was close to cumming so they all prepared and shot their loads into my face and mouth. I felt beyond horny and excited, it was exhilarating. The smell and taste of all the cum released an animalistic level of adrenaline. They all zipped up and went. I was left covered in their cum. Used and discarded. I let it fall out of my mouth down my chest, and I jerked off until I blew my own load all over me. Once I've cum the adrenaline and testosterone driving the whole endeavour departs— and quickly. I'm left with a sobering rationale which is less than favourable. Usually, guilt appears post-ejaculation, or shame. This time my throat felt odd, and so I got up and walked to my bathroom mirror. I spat into the sink, and wiped the cum off my face and torso with some tissue. I could feel a lump in my throat. I picked up my iPhone and turned on the torch and shone it into the back of my throat. My uvula had swollen to twice the size and looked purple. I think the guy who had rammed his cock into the back of my throat had dick punched my uvula and actually burst it. Shit. This was an anxiety-inducing moment. I couldn't swallow properly and it felt like I had a marble stuck in the back of my throat. I ran to the kitchen to drink some water, I threw some ice cubes in it, hoping that might soothe it. I took a pause. A moment to process what

I'd just done, and there was a thought that maybe the kink had possibly stepped over to self-harm. I had caused actual damage to my body, no idea how serious, and the idea of seeing a doctor about this and explaining the cause was mortifying. So I just prayed that it would heal by itself. And thankfully it did. I knew it wouldn't stop me in the future though. This was an effect of my addiction to sex. Like a drug addict having comedowns, withdrawals, infections, track marks... this was just a symptom of my going too hard.

It wasn't just the sex that was putting my body under strain the last 6 months. I'd started drinking more heavily every weekend, taking a lot more recreational drugs, specifically cocaine, and smoking like a chimney. A few weeks ago I got pretty sick, my glands all came up tender and swollen in my neck after a heavy weekend of partying. My body is sensitive and I knew I was pushing it too hard, and past its limit. It was inevitable that my glands would flare up. My sinuses were full of inflammation and cocaine residue. I'd had god knows how much bacteria in my mouth from however many strangers dicks I'd sucked, and on top of that I'd been smoking and drinking nonstop. My body was like 'Sam, please. Give us a minute to clean this up.' I did feel like I was going off the rails a little, in slow motion. I felt sad for myself, but also I was so depersonalised at this point that I didn't really care. My career had sort of come to a standstill. I couldn't find a next step, a next chapter. I wasn't inspired to look for it either. I felt very forgotten about, invisible, almost, overlooked. Everything I'd been through was a recipe for horrendous coping mechanisms. I'm aware of it, and I guess that's a positive first step. I've always said that for me being sex positive, being drug positive, is as much about being self aware of dangerous and unhealthy behaviours, as it is celebrating your freedom to explore them.

Being in control of your kinks, and not letting them control you. Having certain vices can be healthy and fun, until it isn't. I'm still navigating the distance between the two.

Nostalgia

It wasn't so much that I missed it because it was amazing. I missed it because I felt alive. I was truly feeling things. All the good and all the bad. It wasn't like this emotionally absent state that I live in now. It was electric. It was real. I knew it wasn't sustainable at the time, but I guess I never knew it would end so soon. Like all of us, I didn't predict we would be faced with a worldwide pandemic and a total upheaval of everything we know and enjoy about life.

I think of snippets, snapshot moments. They stick out to me a lot. The dark moments sort of disappear, fall through the cracks, as it were, when I cast my mind to look back I only see the sunshine, the laughter, the butterflies of first dates, and the exhilarating feeling of living in a new city. I can see myself momentarily sitting on my kitchen floor crying with a stomach-churning loneliness crippling my every emotion. Making me totally dysfunctional at best. But it's unimportant. In my memory, all the good times shine brighter than the dark times dim the light. I don't think I really accepted it was over when it was. I sometimes wish I'd known that flight would be the last one. Or that night in a crowded bar drinking and smoking with friends, without worrying about a contagious virus, was sacred. Not that I would have behaved differently. I would've just savoured every moment.

I yearn for 2019. The ease and briskness of it all. The spontaneity. COVID took away spontaneity. Everything has to be controlled, assessed, tested, managed, planned. It's not a jump-on-a-plane-tomorrow kind of world anymore. It's jarring how much has changed in a short period of time. To such a distracting level that I don't feel we've all fully accepted it. I live partly numb nowadays. Like a zombie. I live only to survive now. I spend everyday managing things to stay afloat. Both logistically, and rationally. Some days I fear it so much, and some days I couldn't give a shit. I am in a state of trauma preservation in which I've trained myself to feel nothing. Don't be bothered if you haven't seen your friends in months. Don't be bothered if you haven't seen your lover in months. Don't be bothered if you've been indoors for months. Don't be bothered. Be unbothered. The sparkle dims in my eyes, and then in my work, in my love, in my personality, in my sex, and in my heart. I am dimmed. I am desperate to live life again. I pine for 2018. 2019. Thriving. Jumping from one opportunity to the next. Making life happen. Feeling things.

Rotten Apple

A fallen apple rolled across the green, landing at my feet. It was rotten, with browns and reds, and a large crater on its side. Its skin wrinkling in the sun. It too will perish like its siblings around it. I look up to the large tree, I squint, and move into the shadow of a branch that is blocking the sun slightly. The tree is ugly. It's maybe unusual to say such a beauty of nature is ugly, but it is. It's full of imperfections, and the fruit it produces are sour. The apples fall through neglect, jumping the nest to provide nutrients to nothing but bugs and soil. I hate this tree. I always have done. I step onto the rotten apple at my feet, and see the brown mush appear at either side of my shoe. I pick up my foot and drag the rotten apple pulp across the trunk of the tree. Smearing it down. I smash the sole of my foot into the trunk. Over and over. Pounding with all my might. Shaking the branches above just slightly enough to loosen more rotten apples which thud down to the ground around me. Out of breath now, I step back, and turn around. I lean down and pick up one of the apples. I'm disgusted holding it in my palm. I see every wound it's suffered from birds to maggots, every gash on its skin. I throw it as far as I can, sickened by it. It flies through the air, a red dot against a blue sky, moving in slow motion, then disappearing out of sight from me and the tree. I walk away, stopping to look back one more time at the tree. What an ugly, nasty, vile, haunted fucking tree, I think to myself.

ACT V

Wait It Out

After two failed suicide attempts by my mother, me and my family had been forever shaken, yet the chaos had become somewhat ordinary by now. Every time the phone rang you wondered what had happened this time. In the fallout of everything that has happened, I've been left to grieve who my mother once was, what we once had, and face a future without her in it. In this process I have tried to find solace in loving myself, owning and cherishing my identity, being proud of my independence, and most of all learning to fully lean into my queerness. It hasn't been easy, but I've really found escape from my sadness in this. Sex, fun, friendships, and work, all in the queer space, have been a great escape. I think that's one of the wins of being queer, you can have a whole different world at your fingertips you can disappear into whenever you feel. Then the monkeypox arrived. I'd been keeping an eye on the news quite obsessively from the initial reports. Seeing numbers slowly but significantly crawl up. I started seeing pox covered queer men pop up on my newsfeed, then friends started testing positive. Friends contracting it started taking up fingers on both hands. I heard stories of hospitalisations and excruciating pain. I had messages about men spending weeks in isolation wards attached to IVs, and I shed tears while I heard my most grounded friends telling me how they had screamed out loud in pain in emergency rooms. I had men beg me not to have sex: 'Trust me Sam, you do not want this.' I was terrified.

Monkeypox information was varied and non-specific. It seemed like you could catch it just from shaking someone's hand or hugging someone. Every time I searched for information on this I was confronted with not only vitriolic homophobia, but the same conspiracy theory material that ruined my family's life for the past two years. Triggering is an understatement. My anxiety turned into a constant state of fight or flight. Equally, through the noise I could hear queer people shouting 'this isn't a gay disease.' Obviously it goes without saying a disease can't be gay, in 2022 we know that, but the only people I knew with it were gay men. I was frustrated at their denial, and playing semantics over real time data and statistical fact. I was angry at their constant comparisons to the HIV/AIDS crisis and fear of spreading stigma. We had a vaccine for this, and the health services internationally were doing their best to act as fast as possible, despite unhurried governmental inaction. Targeted health campaigning to vaccinate the GBMSM (Gay, bisexual and other men-who-have-sex-with-men) community as soon as possible was necessary in this case, and the opposite to the HIV/AIDS crisis —which was essentially all stigma and no solution. I was desperate to get the vaccine. I signed up as soon as I was able. Before my appointment I was curious about how it worked and possible side effects, so I did a little research. I checked the government website. Ciprofloxacin is the first word I saw. I'm allergic. The one drug I'm allergic to is in this vaccine. I start to panic. I search and scour the internet for answers. Most international health documents state I cannot receive it. I speak to my friend, a doctor, and he encourages me to attend my appointment nonetheless and ask for the opinion of the medical professional on-site. I arrive for my appointment. I speak to multiple doctors. I am refused. High risk of anaphylaxis. I smile and jest that I guess 'monkeypox is better than anaphylaxis.' I

thank them and leave the clinic, going back out into the world unvaccinated, unprotected, and scared. How will I work? I make erotica. 'Well I'll just have to stop for a while,' I tell myself. In a cost of living crisis. 'What about parties? Transmission amongst strangers or friends? Sex is out of the question. So that's that. For how long? Months, I guess.' My mind races. How will I live? Who am I without sex, and clubs, and physical contact, and friends? 'I'll have to isolate myself until it's all over. It can't take so long. It'll reach a dead end soon enough. I'll just get a hobby. I'll wait it out,' I try to convince myself. I start to panic. The reality trickles in. 'What happens if you get too drunk and end up kissing someone one night?' I ask myself. 'Well don't. You can't. You mustn't drink, and you certainly mustn't do any drugs in any situation that you could feel remotely flirtatious or loose enough to put yourself at risk.' I feel my bones shake within my skin. My life as I know it is going on a shelf. I felt like a fiend who'd had his drugs removed. I didn't know how I would cope with everything else I was dealing with, without the escape of sex. Sex would now come with the risk of lesions and extreme pain. Risk of disfigurement. I read the news. Two deaths in Spain. Encephalitis in two young healthy men. Now it's risk of death. To be me, to do the things I love, to do the things I do to escape and to stay sane, to do what I have to to pay the bills, and to feel sexual, and free, and to own my queerness — are now all undertaken at risk of severe disease. As gay men we know this risk all too well. One of my first fears upon discovering my homosexuality was HIV/AIDS. I was confronted in my teens with queer media that consisted solely of depictions of gay men dying of AIDS-related illness, or being murdered. Almost every movie or TV show I watched in my coming of age, presented my own mortality to me. It became very clear my identity was closely linked with disease and death. I carried a huge

fear of HIV and AIDS with me throughout my teens and twenties. It weighed on me like a burden. It wasn't until I went on PrEP in my late twenties that I truly began my sexual renaissance. I could finally have a sex life without fear of an incurable and serious disease. For me, this era lasted around six years. The time between nationalised PrEP and monkeypox was all too short. Too short for a community already stacked with burden. My life as a son. My first role in life was put on a shelf in 2020. It has stayed up there ever since. I have had to grow up quicker, be a man. A role I've never quite understood but had found some vague sense of what it meant to me specifically. In my queerness, I found my identity as a man. Now in 2022 it feels as if the things that made me a proud queer man are also going up on a shelf. Slut-shaming is back in full swing, and the private lives of queer men are publicly discussed by heterosexual people as if they're simple fodder for new discussion or debate. It's as if queer people haven't had sex lives until now, and with monkeypox upon us— like HIV/AIDS— it's time to discuss the rights of gays: whether they deserve them or not, or if they are just as depraved as the forefathers of the fascists before them described. I see my 'perverted' sex life being mocked again. Lowest common denominator jokes about anal sex, straight out of the mouths of boomers in the 1980s, are doing the rounds again. When the streets of major cities are heaving full of thousands on Pride days, it makes it easy not to see that beyond the echo chamber that there are millions who want our right to have sex and love taken away, and in some cases, who want us dead. It's scary to see how quickly our lives are deemed as disposable when an epidemic enters our specific community. It's chilling how quickly the homophobia outs itself when people find out that public money may have to be used to save the lives of queer men. 'Well they should keep their dicks out of other men's assholes,' is their

response to a man who lay dying with monkeypox sores all down his throat, up inside his anus, disfiguring his face, and with encephalitis on the brain, ultimately, killing him. Some of what I read online in 2022 during the monkeypox outbreak could've been quoted straight from New York in 1988. There will never be enough dead gay men for these people's satisfaction, and it takes a virus to do their dirty work for them, for them to admit to this fantasy. Fascism is crawling up around me in society like a black mould infesting the walls of my dreamhouse. Every homophobic tweet or news article I see, a mould spore inhaled. A reminder that I'm not welcome by so many on this earth. My arms shake as I reach to finally put my identity up on a shelf. I want to stand in defiance and be a proud queer slut, to continue showing those who hate us that we're not scared of them, but I know with every potential night out, encounter, friendly hug, kiss, intimate moment, I am at terrifying risk of serious disease—and the only way to protect myself from it is by somehow pretending I'm someone else. Someone who doesn't have 'regular new sexual partners.' Someone who chooses one partner and sticks to it. The heteronormativity is sold as a protection. Something I've fought against for so long is being advertised all around me like screens in Times Square, and, similar to when I'm there, it's giving me a headache. There is an air of irony, that it wasn't a man that had made me consider monogamy/celibacy/heteronormativity (insert sexually oppressive noun here) but a disease. 'Community immunity shouldn't take too long,' the nurse said to me, after I was told I couldn't be vaccinated. So I guess I will wait for that. I will wait with everything crossed that this hiccup is short-lived. I will find a hobby, write and read more, discover a new passion, and force myself to find a fresh love for solo masturbation. I will wait it out. I just hope I don't lose myself in the waiting room.

I am writing a footnote to this essay six months later. I finally managed to get vaccinated. Against all odds, I had it administered in a specialised allergy unit in hospital. The first dose of the smallpox vaccine was found to have great protection against monkeypox, and with current figures, it seems like the outbreak may be over. I don't believe this is the last disease our community will have to deal with, and so I think we should always keep our guards up and act as fast as we did this time. The queer community did an incredible job, queuing up for vaccines, abstaining for a period of time, allowing us to slow the virus and ultimately bring it to a stop. Despite all the vitriol written about us in the summer of 2022, we ignored it all and continued to do what was best for us. Our community leaders fought for vaccines, and we fought hard in a very scary time. I'm proud of the gays for getting shit done so efficiently. I'm proud of the gays that caught this hideous disease and used their voices to stop others going through the same ordeal. I'm proud of us all for doing our best. After all, there will always be something up against us, and we always do our best to fight it.

Storm Headache

Existential thoughts and no air. I walk down Kingsland Road with my skin clammy from the London summer humidity. I have a headache from the pre-storm weather, the pressure on my sinuses is relentless. Can't wait for the sweet relief of rain to fall. I'm going to meet my dad for a beer. We'll talk pleasantries and avoid the subject of his wife for the best part of an hour. Then I'll either drop a subtle 'how's mum?' or, depending on how passive aggressive I'm feeling, 'so I guess mum doesn't care whether I live or die.' He won't respond well to the latter, so I'll probably go with the former. I have to meet him at some vile pub by Liverpool Street station. I'd prefer to go for a drink somewhere more comfortable for me, however him agreeing to meet his son for a drink is a big enough ask as it is. Wherever I feel comfortable he won't, and vice versa. I arrive and grimace just at the look of the place. I see my dad and we go to the bar, an awkwardness between us, and order two pints. After we sit down we, as expected, exchange small talk. His stupidity and flippancy about world events irritates me, as always. For such an intelligent man, I wonder how he can be so stupid. He and my mother bought a villa in Spain, then voted for Brexit. He talks about how my mum has to return from her summer stay out there as she's reached the end of her 90 day allowance in the EU. He claims the EU are playing semantics and being unfair to the British. I explain that entering any country with which you are not in union with, allows you up to 90 days

as a tourist. He shrugs this off. 'Things will change in the next few years.' I'm not sure how he doesn't smell the bullshit that comes out of his own mouth sometimes. 'Apparently it was the same when we were in the EU anyway.' I roll my eyes. 'No. It wasn't. I literally lived in Germany and understood all these rules in depth. After 90 days you had to register if you were living there permanently, but you weren't deported,' I respond. 'Anyway,' he says, 'things will change.' He can't admit he's wrong. Something he and my mother have in common. Heterosexual boomers really just had it all didn't they. Cheap houses, freedom of movement, economic growth. Sometimes I think the most traumatic thing they experienced was the death of Princess Diana. Meanwhile, I lived my entire childhood in the closet with Section 28 only being repealed when I was in my final year of school; dealt with The Great Recession of 2007— the year I left college. Our parents then voted for Brexit to stop us having all the European travel luxuries that they had. Then just after we millennials start getting our lives on track in our thirties, we have to stop everything to protect boomers of dying from fucking COVID. Boomers who then have the audacity to fall down rabbit holes on the internet—traps of which they warned us against—and then ruin the lives of everyone around them. Oh, and to finally rub salt in the wound they give us 12 years of Tory rule which wrecks our basic standard of living, makes us choose between heating and eating, raise the rates of the mortgages we hardly managed to get anyway to a totally unaffordable level, puts all our public systems on the brink of collapse, and pushes our country more towards the far right than ever before. That, and our earth is basically dying beneath us. When I sit opposite my dad, I can't help but see all this. I resent him, and his generation deeply for all this. Even after everything I went through with my mum, he stood by her. 'At the end of the day it's been

35 years of marriage, Sam,' he says. His wife was more important to him than his kids and that was clear. 'I'm sorry to say this,' I begin, trying to hold my tongue but letting my anger get the best of me, 'you're lucky that your mum never treated you the way my mother has treated me. You're lucky that your mum died when you were 26 so you didn't have to feel the pain of growing up to be disowned by her while she was still alive.' He doesn't have anything to say. He looks down and nods. 'I've done a lot of thinking, and I don't think she's a good person. It's a hard thing to come to terms with, especially about your own mother, but I really don't think she's a good person. I think evil runs inside her. She only spreads misery. She doesn't love her kids, she loves herself loving her kids. She is a narcissist through and through who cares about nothing but herself. She wouldn't know for days, if not weeks, if I died. You'd both only find out probably from a friend. Do you know what it feels like to know that if you died your own parents wouldn't know?' He's silent. 'Anyway. She's a bad person and I've come to terms with that now.' I offload onto my dad. In many ways saying all this as a weapon against him. To remind him who he's stood by. To remind him that whilst his kids have suffered by the actions of this woman, he has stood by her, silent. I say all this to make him question his own goodness. Never have I felt such a lack of love. I sit opposite this man like an angry stranger. I want him to know I'm angry. For many things. I want him to feel the coldness coming from me. 'Anyway I have to go. I'm going to Berlin tomorrow and I need to finish packing.' 'Yes me too, I should head off,' he says. Most of the meeting was silence, with passive aggressive statements from me here and there, and avoidant pleasantries from him. We part ways and I feel my nerves, electric. A buzz rushing through my arms, laden with trauma. My heart races and then slows. I feel sad and angry. Disappointed in what my family has

become. What the world has become. To keep my head above water I remind myself that I'm alone in this world, I am responsible for my happiness, my security, my stability. I may have been thrown from the nest but I am independent. I take pride in that.

Compassion

It had been a heavy few days in Paris. I'd never felt further away from my boyfriend emotionally. It felt as if we were strangers, not connecting in any way, and simply going through the motions of a relationship, like small talk over dinner. We'd slide into bed together and fall asleep, with what felt like a wall of cold stone between us. I felt very distanced from him, and he was visibly rejecting this idea. I could see the hurt in his eyes every time I backed away from him, and it hurt my heart seeing his sadness. In a long distance relationship it feels like every time you're reunited you have to work really hard to get to know that person again. Physically and emotionally. You have to relearn things about them that you'd forgotten in the intervening realm. The way they move, the way they do things, what they smell like, what your chemistry is like together, how their touch feels on your skin—I could go on. It's a process that normally takes a few days, your relationship has to thaw out essentially. We expect this, and have mastered it at this stage over 3 years in, but sometimes it can be harder than others. This week was one of those times. I wasn't budging, and I couldn't understand why. He had to leave the city to work for a couple of days, but I remained in Paris, as I had some fashion week things to attend to. I was invited to the Jean Paul Gaultier party, and a friend of my boyfriend's was in town. I asked him to accompany me to it. I thought it could possibly help build a bridge between us, and I could get some

insight into how my boyfriend was feeling. When we went to the party, I was a little underdressed; I hadn't realised it was going to be an affair of that magnitude, but alas, I held my head up high and pretended my casual look was a firm choice. It was an open bar, as most parties are for fashion week, and so we swept the place for every cocktail on offer. After a few spicy margaritas I was feeling pretty loose, and so was my boyfriend's friend. He started to open up a bit. 'How are things with you two?' He asked. 'Not good to be honest. I'm really not sure what to say, it's just not good. I don't feel happy at the moment.' I said. 'I think he feels the same. Maybe you should talk?' He said. The thing is, my boyfriend isn't a talker. I can talk and talk for hours, but he will just listen. It's hard to get his true feelings out, but I knew that he was right. I knew we had to talk, so I decided to set a moment that weekend, over brunch, where we could lay it all out on the table.

We finished our Eggs Benedict and were both sipping on our cappuccinos, when I said the dreaded words no one wants to hear in a relationship: 'We need to talk.' His doe eyes looked up at me, scared, and gave me a look to suggest he agreed. Within a few seconds I had unknowingly opened a Pandora's box of emotion in my head— one that I had been attempting to stifle for months. All the trauma I had been through with my mother came flooding out across the table, making quite the scene as it went. 'Let's get the bill and leave,' my boyfriend suggested, attempting to usher us out of the restaurant before more people noticed that I couldn't breathe from crying. He paid the bill, which I didn't even see happen as I was so submerged in tears, and then he put his arm around me and we left. We crossed the road and found a bench, which we sat upon and talked about our relationship. After releasing all this locked up emotion, it became quite clear that

much of the distance that had grown between us had been created by me as a trauma response to what I'd been through with my mother over the past few years. I had attempted to escape the nightmare through drink, drugs, and sex with strangers, and in the process had lost touch with what and who was important to me. I had started to self-sabotage, and distanced myself from those around me who loved me, because if in forced independence I can be content, then I won't be hurt when they decide to pull away from me. I had truly lost belief in love in the past year, without fully realising it, and it was having real time effects on my relationship. We walked back to the apartment we were staying at, in our own bubble, as if the rest of Paris around us didn't exist. When we got back we sat on the sofa together, and finally, his emotional brick wall collapsed and he started crying. He told me how much he loved me, and that he would do anything for me. He cried at how the universe has worked so ferociously against us ever since we met, with the pandemic, Brexit, closed borders, and family traumas. We hadn't had a fair shot at being a pair, and the fight was exhausting us both. However, acknowledging that we were both tired, gave us a new energy. It gave us a connection and a common ground that we had forgotten existed. It was as if we were both individually fighting for a different relationship because we weren't sharing how we truly felt about being in this one. The moment we shared this battle, we built the bridge that had been missing for a while. We weren't perfect, and things definitely needed work, but unboxing issues that were weighing both of us down certainly helped. It was a new day, and the start of a new chapter.

The following day I was returning to London. After everything that had happened, we had a tearful goodbye. I jumped in the cab to head for the Eurostar, and was replaying lots of our conversation in my

head. I would occasionally well up and would wipe away any stray tears that fell down my cheek. I felt a guilt in how distant I'd been on this trip, considering we get to see each other so little. Ultimately I'm traumatised, and am not processing my emotions in the best way, but it was hard to rationalise this when all I could see were his eyes, full of sadness and disappointment staring back at me.

I went through security and made my way onto the train. 'I'm on board, just waiting to depart now,' I text him. 'Good :),' he replies. My brain is still cloudy with thought.

'Sam, the girls have just let me know that they are all going to be here on Christmas Day, I would like it if you would also like to come home and spend Christmas as a family xx' — a text message comes through from my mum.

My heart jumps and, once again, the air from my lungs deserts me. It is invisible to the eye, but in my body it felt like I'd just done a bungee jump. It had been nine months since I had heard from my mum. No contact at all, and the last time I saw her she had been screaming abuse at me after recently attempting suicide. It was January 2022, I hadn't spent Christmas at home, mainly to protect myself from all the drama, though I think this may have triggered her into an even more severe episode. She attempted suicide twice in one week, and beyond the trauma of that, I decided that we had to step in. The 'crisis team' which I spoke to during all this, a mental health team in the NHS, said they couldn't help her via the referral of a family member (despite her attempting suicide) and that she had to call them herself, or at least be available to speak to them on the phone. So myself, my uncle and

my dad, decided to hold an 'intervention' of sorts, where we could sit down with her, speak to her, and get her to speak with the crisis team. We turned up at the house on a Sunday afternoon, and she was sitting in bed closely resembling something from The Exorcist. When we first went into her room she immediately started screaming at my dad that he'd 'set her up,' and that she needed to get out. She tried to escape, and my dad blocked her from running downstairs. 'We're all here to talk and to try and help you,' my dad said trying to calm her. She became extremely abusive. Shouting horrendous things at me. Vile things. 'How dare YOU judge me when I've seen the disgusting and perverted things you've posted on the internet.' She was talking about my erotic work, which she had been openly understanding of in the past. Her opinion had obviously changed from her new fascist friends. She agreed to go back to her bed. She continued hurling abuse and vitriol at me, my uncle, and my dad. 'Take me and get me fucking jabbed then. Do it. Inject me with the poison,' she was screaming. We would turn to each other in dismay. She continued to insult me, my uncle, and his children. She was saying that she didn't love me, and the only child she loved was my youngest sister, which then triggered my sister to come in to the room and start screaming about how if she loved her, she wouldn't have left a suicide scene in the bathroom for her to find, which consisted of bloodied razor blades and an extension cord leading from the bath. It was an alarming sight for me to see my youngest sister like this, swearing and screaming. I had never seen it before.

My mother then turned to me, in a calm and chilling voice, and said what was probably the most painful out of all the things she said that day, 'I don't think you're a good person.' At that point I was so

desperate to escape the room, the pain and hurt so unbearable I could feel my body almost shutting down, that I glanced outside the large bedroom window to the left of me. At the back of the garden, across from the house there is a field, and to the sound of screaming I saw 5 bunnies chasing each other on the green. They were running around in circles, playing and jumping. I couldn't quite believe what I was seeing, and for a moment I was transported outside of the madness. I wasn't here anymore, I was in better memories, full of laughter and joy. I remembered Christmas mornings in this bedroom, opening silly gifts and throwing bundles of wrapping paper across the room. I remembered sneaking into this bedroom to borrow some of my mum's hairspray. I remembered watching my youngest sister being born on this bed, and holding her when she opened her eyes for the first time. I yelled 'she has blue eyes!' And my exhausted mother yelled back 'all babies have blue eyes!' For a moment, I had clarity of the beauty in this life, the humour and sweetness, and that gave me the ability to catch my breath, ground myself, and bring myself back into the room.

I told her she needed to take this call with the crisis team or she would never see me again. There was a stillness, and after my dad firmly encouraged her, she agreed. My dad had the team waiting on the phone, and she agreed to take the call, but when she did so she took the phone and locked herself away in a bedroom. 'I've been cornered in a room by all the men in my family, I'm the only woman here and they've cornered me in a room and won't let me leave.' Her manipulations met no end, and I felt disgusted by almost everything that came out of her mouth. Luckily for us, it only took a few minutes for her to start relaying anti-vaccine and other conspiracy scripture down the phone to the crisis nurse. The phone call lasted about an hour, and it was then

passed back to my dad. She returned to bed, and my dad finished the call. My uncle and I were waiting downstairs at this point, and my dad came down to tell us that they were going to be sending a team around the following day. I felt a relief, finally we were getting the help we so desperately needed as a family. I decided to get my things and return to London. I was exhausted. It was really dark at this point, and only a moment after getting on the train I cried and cried for the full hour of the journey back. I had been traumatised. The day, in all meaning of the word, had been absolutely traumatising for me. For the next week I cried every day reliving the things she had said to me that day. I cried because I didn't recognise her. I cried for who she once was, which seemed like a distant memory. Then I wiped away my tears, and tried to move on with life without her.

Nine months had passed, and the world around me stopped on receiving this message from her. I tried to slow my breathing to focus on my thoughts. I tried to ask myself questions. How did I feel? What did I want to say? What should I do? What was my gut telling me? All I could recognise was the happiness deep down receiving that message. Of course I wanted to spend Christmas with my family. Despite all my misgivings, this is something we all want, to spend time with our family. That was something I wanted deep down. I also knew that my mother didn't do apologies. This was an olive branch and it had to be taken as such. Did I want to run face first back into all that chaos again? Absolutely not. However, could I care for my needs while retaining my boundaries? Absolutely. The one thing I dug deep for in that moment was compassion. Compassion for a woman that was very unwell, and though she had hurt me, she was hurting also and was clearly desperate to build a bridge with her son. There is happiness to be

found in compassion. I have only found darkness in grudges, anger and hatred. It solves nothing. Finding compassion for her, also meant that I was caring for my greater need for a relationship, albeit not what it was before, with my mother. I could sit and let this message from her digest, think more about what I wanted to reply, or I could go with my gut and say what I meant. The games can end with me. I keep it real, and I set the boundaries.

'I'd like that, if I'm welcome x,' I text her back.

It was truthful and from my heart, and in a similar way that I'd experienced with my boyfriend that week, I felt the weight of the world lift from my shoulders at that very moment. I felt freer having allowed myself to find compassion for her. I took peace in believing that for the most part she is ill, and maybe knows not what she says. Not all can be excused, and many things are due accountability, but I know that will likely never come, and expecting it is only setting myself up for disappointment. I believe that I must discipline myself in setting realistic expectations and boundaries if I want a relationship with her moving forward. Regardless, she is my mother, and I will have to live with her emotional burden, whether she is dead or alive, forever. So I must choose a path that attempts to allow me as much peace as possible in that quest. No matter all the trauma and suffering she has caused me, a new door has appeared, and compassion was my key to seeing what lay behind it.

June

 I received a random message in my inbox from a boy with a slightly cryptic message, along with 2 photos. 'Hi Sam. Bit of a weird one, so apologies in advance. Going through a relative's possessions and she had a news clipping and a signed picture of you from 1998. Looks like it could be you?' I open the attached photos, and it is indeed a signed picture of me, and a news clipping about my time in Oliver. Funny seeing a headshot of me at about 10 years old, on which I'd signed 'Love from Sam Morris' with my name underlined, separately, in an almost condescending way. I was suddenly intrigued about who this person could be? How on earth had they obtained this? I assumed they'd died due to the fact he was going through their possessions. I asked him who it was that owned it. The suspense was killing me, but after a short while he replied 'It turns out my nan, June, was neighbours with your nan, Edith.' More innocent than the chaotic unveiling I was secretly hoping for, but a cute story nonetheless. I decided to send screenshots of this interaction, along with the photos to my uncle, my nan's eldest son. I knew he'd know who this person was, and thought it might amuse him. My phone started ringing almost immediately. He's of a generation where they jump on the phone to talk, always unnerving for a millennial, but I figured I'd answer. It was close to Christmas and I was feeling generous. I used to spend every Christmas with my uncle and aunt; in fact as far as I can remember, my uncle and aunt have spent

every Christmas with my family ever since I was born. He's a bit of an obnoxious and difficult man, argumentative with old-fashioned and problematic views, but frankly he's not long for this earth now. He's struggled with Multiple Sclerosis his whole life, miraculously managing to get well into his 70s with it, pretty much by using that stubborn personality to not let it debilitate him any more than he'd allow. He walks every day, and has done religiously for years, to try to keep the MS under control, and it's worked pretty well. He's the only remaining sibling that is left of my mother's, but unfortunately, like the rest of us, he was cut off and estranged also. I answer the phone and he tells me who it is. 'Yes, I know,' I say. 'Your name comes up when you call.' 'Oh I don't understand all that stuff' he replies. He asks me on the phone what I'm doing for Christmas, I say that I'm very tentatively going back home. The last time I saw my mother was with him, in the exorcist room, with her head contorting 360 degrees while she flung out horrifying remark one after the other. He reminds me of it. I reiterate it was one of the most traumatising days of my life. 'I'm not surprised Sam, it was awful, no mother should ever speak like that about her kids.' I felt validated that he'd said this. Despite having nothing in common but blood, we could both agree on this. 'She says that our mum was terrible, and did awful things to us, but our mum never would've said those things. The things your mum said about you were reprehensible.' It scares me hearing this truth so close to Christmas, because I'd buried so much of it to be able to cope with going back, and to find compassion for her. I'd been attempting to be strong for my sisters, so we could try and create a happy family structure for a day, even if we all knew it wasn't real. 'Well the last time I saw her was that day with you so… I'm pretty nervous,' I said. He isn't surprised. 'What are you two doing for Christmas?' I ask him

224

nervously. I often feel like I'm carrying the guilt of what my mum has done to all of us. 'I think it's just going to be us two. It's hard with the kids jobs and train strikes etc you know? So just us two now I think.' I feel a pang of sadness hearing this. These two older people spending Christmas alone, shunned out by my mother, yet more casualties of this nightmare. 'Well you're probably in for more peace than me,' I jest. 'It does make me sad though, Sam, my relationship with your mother wasn't just like brother and sister. I was the dad she never had. I paid for her to go to ballet school. I've always been like her father, and I've looked at her like somewhat of a daughter my whole life. So I am sad about it. I'm not gonna be around for long, and I just hope she doesn't regret this.' My heart breaks in two hearing this, and I'm starting to relive so much of my own trauma from the last year in his words. My throat is suddenly choked up and my eyes fill up. 'The last time I saw her was a few days after that time we were there together in the bedroom. I went to the house to check in and see how things were. Your dad let me in and I sat in the kitchen, when she came downstairs and saw me she said 'what the fuck is he doing here?' It was horrible, Sam.' He said. I can hear the pain in his voice. 'I know, trust me I know, I just don't think she's present anymore, I think she has some sort of brain damage or something honestly who knows,' I responded quickly, trying to move it from an emotional place to a more rational one. 'Yes, well…' I knew this would stump him, which is why I said it. 'Well if you find yourself needing to escape this Christmas then we have a spare bedroom! You're always welcome to escape to here.' I could hear in his voice the hurt buried in this offer. He'd be straight over ours for Christmas if he was invited, and instead, like so many others in our life, he'd been shut out. He's an old man, and despite all of his imperfections, he doesn't deserve this. I'm welling up on the phone to

him. Sat on my knees on the floor, trying to hold it together, pass it off with banter. 'I'll be over in a cab if it all kicks off, don't worry about that!' I attempt to laugh it off. 'Yes, do, you're welcome whenever,' he says, intent on making my tears flow. 'So, what's the deal with this woman with the signed pictures of me? This 'June' woman that knew my nan, your mum?' I change the subject gently. 'Oh yes! June was a friend of your nan's! She was her old neighbour. Big Fat June, that's what she called her. She was a very large lady.' I start laughing. I was not expecting that. 'Yeah, she wouldn't stop going on about Big Fat June. 'Off to bingo with Big Fat June' she'd say 'had a great time in Southend with Big Fat June.' It caught me so off guard, I couldn't help but laugh. 'Oh god. Well I definitely don't think I'm gonna message that boy back and tell him my nan's nickname for his nan.' We both laugh. A sweet relief. Delivered from heaven by my naughty nan. 'Your mum would know her too, I think she was friends with Big Fat June's daughter,' he said. 'Well maybe I'll keep this in my ammunition for Christmas, if I'm alone with my mum and in need of a funny story,' I said. 'Sounds like a good plan, keep that one in your back pocket,' he says. We both laugh. I wish him a Merry Christmas, and after he tells me again that I'm welcome in his spare room, we say goodbye and I hang up. I sit still for a second, and rub my eyes. I felt sad for a moment, thinking about the pain I shared with my uncle in all this mess. Then I pause and suddenly think… Big Fat June. I giggle and shake my head. Fuck's sake nan.

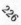

Brighton

In an impulsive moment of clarity I decided that remaining in London wasn't conducive for a healthy life. I was burning the candle at both ends and making decisions that were regretful. I was textbook in my handling of the events of the last few years. I was drinking more than ever before, and every night out was resulting in my nose vacuuming up any white powder I was offered. I had gone pretty much my entire twenties without touching drugs, and I lived in Berlin for the better part of 3 years and could count on one hand the amount of times I took drugs there. However this year in London it got to a point where I was consuming substances weekly, if not a couple of times a week. It went from me being in control, setting boundaries, to me not knowing how to say no to a good time, taking any old thing I was offered in a toilet cubicle, and staying out until 10am the following day. I learnt how to pick up drugs, because I thought if I had my own I'd be able to better control what I was taking and when. This was a fallacy. It actually just gave me easier access to the drug. I'm talking specifically about cocaine. However, after using for a few months, I started to realise what was pure and what was cut with something else. Most coke you get is cut with mephedrone, and you'll know because your jaw will start swinging. I'd had some pure coke on my drug journey, which was nice and makes you super alert and chatty, but you don't gurn your jaw down to the bone— this was a rarity. Regardless, after about nine

months of partying and using, I started to feel uncomfortable about my behaviour. I was getting really run down from missing full nights of sleep, giving me an unsightly cold sore almost every week, and my anxiety was totally insane. The hang-xiety from alcohol is bad enough, but mixed with coke, it is absolutely brutal. I started to feel deep shame and regret about my behaviour. There was one particular weekend which was a hard smack of reality that I needed. It was London Fashion Week, and I was very overstimulated going from show to show. I was buzzing from the energy of it all, and for me, the week it was like a red rag to a bull when it came to going out, drinking, doing drugs and attempting to keep that buzz going. I went out every single night over a three-day period, with the final night overstepping a mark even I didn't predict. I went to a party that had a darkroom, and when I've been drinking or taking drugs, I will be the first person in and last person out of it. Nothing excites me more than disappearing into those spaces and reaching peak hedonism. Naked bodies everywhere, shame nowhere, everyone just submits themselves to their animalistic desires. By the time I went into this one I was already pretty high. I'd also just come back from Berlin on a trip, so in my drunken stupor had forgotten I was in London where drug rules are much more strict in general, particularly in clubs. There were attendants in the darkroom, but I thought they were an awareness team. In Berlin, you have awareness team members that will overlook happenings at the club in case of drug overdoses, but they are there for you, not really the club. These were not that. They were there for the club. While I was standing, cock out, having my dick sucked by a guy on his knees, I decided to pull a bag of coke out of my pocket, and a key, and start digging for a bump. All of a sudden a torch light shines on me, illuminating the darkroom, which then saw everyone scurry like rats in an alley. 'Absolutely not, you need

to leave,' the attendant says to me. 'Oh my god. I'm so sorry. Here take them, I fucked up, sorry.' I pleaded with him. This attendant looked about a decade younger than me. 'No, you need to leave immediately. Get out now or I will call security and have you removed from the club.' I accepted defeat, pulled my clothes back on and walked with my head down out of the darkroom. The shame was heavy and real, and the alcohol and drugs only accentuated it. What the fuck was I doing? I saw some friends after in the club and they told me to calm down, not be so hard on myself, and that I was over-intellectualising it. It was definitely partly true, but for me the incident was a step over a line and I was feeling pretty mortified about it. By the time the party had ended it was 6am. I waited and loitered outside for ages trying to get a car. There were no Ubers anywhere outside the club, and so I decided to walk home. It was well over an hour's walk, and so by the time I actually got home it was 8am. I went in and hit the pillow. I had a fashion show at 5pm that I was due to attend, and at this point I hadn't had one full night's sleep in 3 days. I fell asleep almost immediately and woke up at about 2pm. My body was all over the place, and exhausted. I wasn't eating properly these days, and was having a small breakfast I could just about stomach in the middle of the afternoon. I looked like death reheated, but had to put on a full look for a fashion show, do my hair, and make myself look half presentable. In a daze I managed to get my shit together, but it felt like I was dreaming. I hardly had the energy to stand up, so I would sit down now and then just to find some energy. I couldn't not go to this fashion show—as it was 'important' —so I dug deep and called a cab ready to go. Just before I was about to leave, I decided I needed to do a line of coke, to give me the energy to actually get to this show. I snorted a line and got into my cab. In the car on the way there my chest was hurting. I had aching pains rushing across my

chest, putting pressure on my ribcage from the inside out. I'm gonna have a heart attack in the front row at a London Fashion Week show, I thought. The embarrassment. I actually could not think of anything more embarrassing than that. I arrived at the show, smiled when I saw some people I knew. I prayed that the time would move fast, but with this show being such a huge spectacle, it was taking much longer to get going than a usual show. I took my seat, and my chest was literally hurting. Pangs of pain were shooting across my sternum. I kept rubbing my chest, pretending I was fine. This is too much, I thought. I'm going too far and need to slow down. This isn't ok. The show ended, a friend there said there was an after party: 'Would you like to come? Should be fun?' He asked. 'Absolutely not, I'm afraid. I had a late one last night. Need to go to bed.' With that, I quickly headed into my Uber. I went home and went to sleep. For about 14 hours. The following week I struggled to cope with the guilt and shame of that weekend. I was ashamed of my behaviour, and it felt unfamiliar to me. It was clear I was struggling with my own reality, my own life, and seeking escape. I was choosing self-destruction as not only a coping mechanism for depression, but also as a celebration of joy. When I was feeling a buzz of happiness, I immediately wanted to go out and be as destructive as possible. When I was feeling down, I wanted to drink and escape as much as possible. None of it made sense, but I knew I needed to take my foot off the pedal. It was in this decision I decided to relocate to Brighton for a while.

I've been in Brighton for a few weeks now writing this. I haven't smoked a cigarette or touched drugs since I've been here. I've been writing a lot, going for runs down the seafront in the morning, and most notably, sleeping better than I've slept for months if not years. There

is a peace here, a slowness that I've needed. I'm not sure how long I'll be here for, but for now this is the medicine I've needed. I am feeling more productive, less messy, and more focused. I am taking the time to allow myself this quiet. Seeing the sea every day, reminding myself of the greatness of things beyond my control, and how, despite that, I still have the ability to control the things I'm able to. Choosing things which are better suited to me. All night parties and drugs has never been my scene, I'm not suited to it. Is it fun? Yes, a lot. Too much at times, and my mind, body, and equilibrium pay the price, and quickly. There is a danger of wandering into a world of substance-fuelled fun that makes us feel unappreciative of the smaller pleasures in life, and I walked perilously close to that territory this year. Do I think this quest for the quiet life will last? Probably not. I know what I'm like, and I tend to not stick to anything for too long. I'm a city boy, and no doubt will crave the hustle and bustle soon enough, but I don't think it's a bad idea to take breaks now and then.

My plan now is to find purpose, because in purpose, self love will prosper. I put a lot of my recent behaviours down to a lack of self love. I felt loveless, and I attempted to fill that hole with everything I could— but love. So for now I will attempt to look for a buzz in a beautiful Brighton sunset, a frothy cappuccino, a hot dog at the cinema, or the smell of donuts on Brighton pier. The small things are just as important as the big things, and I need to keep hold and sight of them.

Work In Progress

I returned home for Christmas, as I'd planned to and agreed, with great apprehension. I'd spent the weeks leading up to the holidays dealing with a great unease in my gut, wondering if I was making the right decision, what was I to expect, how would I cope with any confrontation. My sisters were all pretty calm in the lead up, and encouraged me not to worry about it. They were confident my mum would be on her best behaviour— whatever that meant. It had been two years since I'd spent Christmas with the family, and even the previous time my mum had spent most of the day in the corner crying. I made the nervous journey to my parents by train, and was reassured that my sisters, their partners, and my dad would all be there when I arrived. Upon walking up to the house from the station, my dad drove past me in his car, going away from the house. Great, so that's one less person to soften the blow of being at home with my mum for the first time in a year, I thought. I started panicking, it was getting more real, the closer I got. I walked into the street where my parents lived, and from a distance I could see my mum standing outside the next door neighbour's front door. This was not how I wanted to see her this holiday: alone, outside, and in front of a neighbour. My heart started racing, I paused for a minute, trying to get my head straight and then started walking towards the house. The neighbour noticed me over her shoulder, and upon hearing my suitcase wheeling across the pavement she turned

around. Her face looked cold, but she smiled at me nonetheless. Her smile looked like it belonged to a friend you'd fallen out with, trying to make amends. I smiled back. 'Hello! I'm just going to drop my case off inside, so…' I said. She didn't say anything, just smiled and went back to talking to the neighbour. I get into the house and nobody is in there. The house is silent and my heart begins to beat faster. The last time I had been in here we were trying to get my mum sectioned. I text two of my sisters saying 'where are you?' I am pissed now. I'd been promised I wouldn't be alone when arriving here. I heard one sister upstairs, she'd just got out of the shower, and was getting ready. My two other sisters messaged me to say they were on their way. I had really expected there to be a cushion of at least 5 people when I arrived, and instead it was just me, on my own, waiting for my mum to come back home from next door. I was extremely nervous, shaking almost. I went upstairs and hid in the bathroom. This wasn't how I'd planned this reunion in my head, and so I needed to figure out how I was going to deal with it. I reminded myself of compassion. My plan to have compassion. Compassion, compassion, compassion. Focus Sam. I hear my sister downstairs with my mum now. 'Where is he?' She says. I realised I couldn't hide in the bathroom forever and needed to go down. I took a deep breath and slowly walked down the stairs. Hoping each step would take an hour, so by the time I got down there, the room would be full of people. I reach the bottom step and it's just three of us. This was sister two: a sister I'd clashed quite badly with over the situation with my mother in the summer of 2020. They'd always had a terrible relationship, then in the last few years, it was like they suddenly became best friends. The child that always had the most problematic relationship with our mother, had suddenly become the favourite, and despite all that went on, I think she enjoyed playing this new role. She tried it on

for size, and liked how it fit. She seemed to revel in it, and develop empathies that didn't exist with her before. This new relationship came with biases, and it caused us to butt heads, with us taking different sides on different issues. Narcissistic parents are masters at pitting siblings against each other—this almost seems easier when the age gaps are as large as they are in my family. It's impossible to all have had the same lived experience. I grew up in the 90s, very poor, with an unmedicated mother, living under extreme circumstances, whilst being quite strongly disciplined. My sisters were then born; one when I was 7, then when I was 11, then the youngest when I was 16. We are totally different generations, who've seen our parents in very different stages of life. My youngest sisters pretty much got away with murder growing up. To a neglectful extent. That was simply not my experience. I'm not saying they didn't have their own difficulties, but they were under different circumstances to mine. At least about up until 2020 when everything changed, then we all got dealt our own fair share of trauma. However, this particular argument with sister two that summer had been caused, essentially, by how differently we felt about our mother's behaviour, accountability and mental health. I have no doubt that my mum is mentally ill, but it was my belief that this shouldn't excuse her lack of accountability for certain behaviours. On top of that, I was very familiar with my mother's histrionics growing up, and after doing a lot of work in my thirties to look back and critique my upbringing, I had less sympathy for my mother now than my 20 year old sister. The argument was horrible, very aggressive, and it ended up with my sister screaming in my face, and me not speaking to her for over a year. It's sad because it felt like this was a design of my mum's making, and I carried a lot of sadness about that for a while, alongside everything else. We did however reach out to each other and patch things up over

the last year. That being said, I would've preferred it not be just me, her, my mum, and a Christmas tree on this particular day, after the turbulent year just passed. My mum and I exchanged some small talk, I couldn't bring myself to look up at her. I'm not sure why, and it made me feel like shit, but just looking at her face made me feel so angry and sad, so I tried to avoid eye contact and talked whilst looking around the room or at my feet. It felt like a lifetime of disconnected and meaningless chitter chatter, and painfully awkward silences, until the rest of my family started to arrive. I had rehearsed how I was going to cope with this day, and it was absolutely nothing like it. Now I felt angry and disoriented. I started to feel all of the hurt, pain, trauma, and anger from the past two years boil up inside me, and I had to use every inch of me to suppress it from bubbling up over the edge. At one point I went upstairs to take my suitcase to my room, and as I passed through the hallway, my mum came out of the bathroom. I continued on to the bedroom, hoping she would just go downstairs, but she followed. I don't actually remember what she said, because I immediately started to open my suitcase, hoping that I would fall into it and disappear into an alternate universe. I think she was saying something to try and start a conversation, like 'How is Brighton', or 'I hope the train strikes didn't cause too many issues getting here.' For the most part, I replied with one word answers. I couldn't process what was happening, and I suddenly started behaving like an infant. The last time I saw this room, my mother had locked herself in it to speak to the mental health crisis team, cursing us all in the process. Being so confronted by the events of that day, I could do nothing but grunt short replies at her attempts at handing out an olive branch behind me. I didn't even turn my head, like an insolent teenager, I moved stuff around in my suitcase whilst nodding with the occasional 'uh-huh'. I felt like a dog, shivering from past abuse,

too scared to trust and believe in kindness. Eventually I heard her stop trying, knowing that her attempts were falling on deaf ears, and she left the room and went back downstairs. I sat on my knees and silently cried into my suitcase. I wanted to run after her and hold her and never let her go. My heart broke for her and everything she had brought upon herself and all of us. I sobbed quietly on my knees alone in this room, mourning my relationship with her, grieving all that had happened. In many ways her lack of acknowledging what she had done, the lack of apology, the 'just pretend it didn't happen' made me even sadder. It was like I could feel her shame, and then I felt guilt for my anger. I felt so mad for all she had put us through. It reminded me of all the times when I was a child and she would scream and scream at me, and I would hide away from her, then when I'd find the courage to creep out of my bedroom and go downstairs, she would be smiling, starting conversation, as if nothing had ever happened. I was always being pushed and pulled emotionally, and it was totally bewildering. On this day, I could've been 34 or 14, it was the same emotional chokehold she's had me in my whole life, and it was manifestly present this Christmas Eve. I wiped away my tears and pushed all my emotions down and away, deep inside. I went back downstairs and attempted to join in the festivities. For the most part the rest of Christmas was pretty normal. We would eat, drink, exchange presents, play games. My mum seemed to be behaving very well, she would continue to make more effort with me, which I often deflected for the first day, until I warmed up a little around Boxing Day. I'd engage a little more with her advances, playing along with everyone's game of pretend. Occasionally I would see her sitting alone somewhere, with a look of sadness upon her face, and my emotions would rise from the deep far away place I'd hidden them, and I'd have to go to the bathroom to compose myself. For some

reason, her loneliness in this chaos was a big trigger for me. By the third and final day, things from the outside looking in would've appeared like any normal family Christmas. There were a few comments from my mother, about things like natural remedies instead of 'big pharma' and how using black CBD oil had cured her friend's sprained ankle. Small things in comparison to what we'd been used to in the past, but of course now we know better, and nobody took the bait when she offered these tidbits to conversation, we would just nod and change the subject. I guess there was an element of progress in her not continuing to pursue the topic; in the past she wouldn't have stopped, but this time she did. The landscape of Christmas also looked different as there were now missing family members due to them being estranged by my mother. I wasn't sure when I'd ever see them again, most likely at one of their funerals, but aside from these things, Christmas for the most part all appeared normal. When I was leaving on the final day, my dad gave me a lift to the train station. My mum hugged me goodbye and said 'thank you for coming back this Christmas, it was really nice.' 'No worries. You'll have to come down to Brighton sometime soon,' I said. 'Thank you, I'd love that,' she replied. I grabbed my stuff and got in the car. I think if she always behaved like a sinister, vindictive, malevolent villain, it would be a lot easier for my hatred to find purchase. A hatred that would help me find clarity and move on from all of this. The hardest thing with her has always been the see-sawing between the two personalities inside her head, because one I hated, but the other I loved. It was like there was a toxic relationship within her mind, and I felt great sympathy for the one that was trapped. I got in the car to go to the station with my dad. 'Well mum seems in better spirits,' I said. 'Yes, she seems to be doing better,' he said. There was a silence between us, as always. 'There were still a few…naturalistic talking

points I picked up on that she was trying to push,' I said. 'Oh yeah. Her naturalistic friend, Karen, you know the one with the healing business, on the same train as your mum all through the pandemic? Well she had stage 4 cancer. She refused chemo, wanted to go with an all natural approach. Anyway she's dead now,' my dad said. 'And your mother has said she'll do exactly the same if she has the same fate.' This wasn't news to me. I'd had arguments with my mum pre-2020 about the fact she said she would refuse any official cancer treatment and go an all natural route. I used to call her selfish for saying it. Little did I know of the alt-right pipeline that would lead her down, the roots these naturalistic beliefs would come to have, triggered by the pandemic. 'I have to say, with everything that's gone on, there were times this Christmas at that house, where I felt like I was in the Truman show.' I couldn't hold myself back from saying it. 'I know, but what can we do? We all just want to move on. There has to come a time where you have to draw a line and move on, otherwise we'll keep going back in circles, and it's just a never ending hell,' My dad said. I paused. 'I agree.' I said, and I did. Despite my feelings, I did agree with him. It's just a very hard thing to accept in many ways. Accepting all that has happened, forgiving in a sense, and moving on. 'I'm just disappointed that I've lost all my friends, I've lost everyone we've ever known. Ya know? We can move on as a family, but everyone else has gone. There's no one left. The damage is done. I missed my niece's wedding because my brother said he didn't want my wife there. What was I supposed to say? She's my wife. And now it's just us two because everyone has gone,' He said. I didn't know what to say. We were all dealing with our own specific traumas in this family because of what had happened; sometimes we were able to relate to each other, and sometimes it felt like a competition. 'Yes. Well. Moving forward I guess we all need to do our part to try and

repair what she has destroyed. Things will never be as they were, but we can all do our bit now to try and fix a few things,' I said. I did believe this. Things would never be the same again, ever. We were all traumatised in our own ways, but, as my dad said, eventually you have to draw a line and move on. Choose peace. Even though there were many times this Christmas I felt like things weren't real, or that we were all pretending, sometimes maybe you need to pretend until it feels real again. It's very easy to say how you would cope with something until it happens to you. I don't think I've coped with what has happened over the last years exceedingly well. Should I have made online videos documenting what happened with my mum? Should I have done an interview with a journalist? Should I even be writing about it now in this book? Maybe not, but I've spent most of the last few years alone— and I mean totally alone—trying to deal with it. I've had no help, no where really to turn. My friends were sick of hearing about it, and my family were too close to it. One day you might want to talk to a sibling about it, but they don't want to be triggered or talk about it that day, and vice versa. My mother attempted suicide three times this year, and it got to a point that you'd have to use humour attempting to tell a friend about it again, because it felt almost far-fetched. 'Yeah, she tried to drown herself in Spain this time! She went out to sea in a rubber ring naked at night, and after my sister panicked, my brother-in-law had to go out and rescue her, bringing his naked mother-in-law back to the beach in his arms' I'd tell a friend, laughing it off, whilst inside my brain I was feeling shell-shocked by what was being recollected out of my mouth. There were times I reached such lows that I even called the Samaritans, a suicide line, and nobody answered. The line rang and rang, and nobody picked up, on multiple occasions. Which did, admittedly, rattle my macabre sense of humour once I felt more stable again. You go on

masking and suppressing your emotions, as you think it's the only way to deal, but eventually they have to come out, and I've learned that they almost always come out in unhealthy ways. Drugs, alcohol, sex, or *insert form of potentially unhealthy escapism here*. I am now focusing on doing my best to overcome this trauma, and I believe that despite the complex nature of my family situation, I did the best thing by going home this Christmas. I think it was potentially the first stitch in a vast wound, and I hope that the stitches continue. It'll never disappear; there will always be a whopping great scar left in our family from all this, but we can at least try to heal. I've left an open invite for my parents to come visit in Brighton, and I'm going to attempt to start therapy again here to try and make sense of some things. Find some better coping mechanisms. I feel sometimes whilst trying to seek peace, we can accidentally gaslight ourselves. I'm struggling with that on this journey. Life is a never ending work in progress. We're thrown things when we least expect them, at the worst times, that test the tenacity of our spirits. I do believe that without the gloom of darkness cannot come the joy of light, and remembering that one cannot exist without the other can help to keep us balanced. I have had a little too much gloom for my liking, and so I'm hoping more joy is on its way. So I keep working, learning, and discovering, with each year, but ultimately, I just keep on keeping on.

Healing

It was a very foggy morning in Brighton. I could barely see the trees across the square from my apartment. I'd woken up early for my 9 am therapy appointment. It was just a consultation, and he'd managed to squeeze me in at short notice. I'd tried therapy on and off in the past, with little luck. The longest I stayed in it was about 6 months. The previous times I'd accidentally signed up for psychoanalysis, and for the most part that felt like I was talking in a room by myself. In psychoanalysis you're essentially given nothing, you have to unpack everything by yourself, build your own road to self discovery. It didn't work for me. I would end up spending 50 minutes talking utter shite trying to fill the painful silences, and evade the awkward stares of the nodding, mute therapist. It takes a lot to start therapy. I'd scour the internet looking for a therapist. I would search terms like 'gay therapist Brighton' and then wait for a friendly face to pop up. I very much judge a book by its cover in this process. Obviously I know this is a terrible way to choose a therapist, but if their energy doesn't feel right in their picture then I simply cannot bring myself to email. I also felt in need of a gay man this time. My past therapists were a cis straight woman, and then a cis straight man, and both ended up with me in disagreements with them about my interpersonal relations with men— to the point I once found myself arguing with the male therapist about our difference in beliefs over monogamy. 'This isn't a church, this is

a therapy session,' it ended with me saying. It's very overwhelming trying to choose a therapist to email. There is a lot to consider, a lot to read, including your budget, and if they specialise in what you're looking for. What am I looking for? I ask myself this while I'm scrolling through the endless therapist ads. It's exhausting starting therapy from scratch, wondering where to start, what trauma to unbox first. I decided this time my need for therapy, here and now, was for trying to process what the fuck I'd been through in the last few years with my mum. I was becoming terribly pessimistic, I'd lost my drive, and I'd developed some seriously unhealthy coping mechanisms. I finally found one, on the second page of scrolling, a gay man that looked very friendly. Had a warm face, and kind eyes. His bio had a lot of buzzy words that spoke to me, and so I hit email. He got back to me shortly and I booked an in-person consultation appointment for just a couple of days after. Having a Zoom meeting was also an option, but I'm absolutely sick of them post-pandemic, and avoid them at all costs. My brain needs a physical, tangible meeting with someone to register it as a real interaction. Anyway, that was a relief. I'd done it, found someone, got the appointment, now to get the healing ball rolling. I walked to his office, over in Hove, picking up a coffee on the way. He'd said not to be early, and to arrive just on time. Therapists always say this. My mind runs riot wondering when to arrive. So for a 9am appointment, do I arrive at exactly 9am? If so, by the time I've made it up the stairs and in the room, I'll already be eating into my time by just taking my coat off and sitting down. That's no good. 8.55am is probably too early. That'd make me a few minutes earlier than what he's requested, so inconveniencing him. 8.59am could work. Exactly 8.59 on the dot it is then. I wait outside the door until 8.59am, going between my iPhone time and my wrist watch time, making sure I'm as accurate as possible.

Then in the 30 second countdown between 59 and the hour, I ring the doorbell. Right on time. Perfect. I think this process alone, that I put myself through before any appointment I've ever been to in my life, is a good enough reason for me to be in therapy. I climb the stairs and he's waiting for me there, as expected with me being perfectly on time, and he welcomes me into the room. He does seem very warm and friendly, as his picture suggested. So far, I think I had read him right. He asked me to take a seat on the left hand side, and then he took my coat to hang it up. He sat down opposite me and asked me what had made me want to come to therapy. I always hated this question, but it was obviously inevitable and necessary. In answering it I always felt like a car starting up in the snow. It was usually a brutal task, but this time I was fairly efficient in getting started. I listed off all the traumas I'd experienced in my life like a to-do list. 'And so yeah basically that's it I think,' I said upon finishing my list. 'I just need some help because I'm struggling to process everything and see a future right now.' I tend not to look at people whilst I'm talking, so when I finished my little trauma introduction my eyes circled back to him and I could see his very sweet eyes had widened quite a bit. They looked glossy almost. 'That's a huge amount you've been through, and I actually feel quite emotional hearing all of that.' I guess it was a lot, I thought to myself. I guess it is emotional. The way I said that my mum attempted suicide 3 times in the last year was so nonchalant, like I was reading an item off a shopping list, that it even caught me off guard afterwards. I'd closed down so much to be able to cope with everything in the last year. I'd stopped processing my feelings so I could continue to function and pay my bills. It was like I hadn't been living my life and I was pretending all this trauma belonged to someone else. I was aware it was happening to me, but I wasn't really feeling any of it. It was like I was playing a part

again, to escape. 'I'm here to listen now. That is my job, and I'm here for us to better process all of this. This is a safe space,' he said. This was the first time I felt like I'd landed back in my shoes, and I was me again, speaking aloud all of the things I'd been through. I was scared, terrified even. Yet, somewhat relieved. I really warmed to his energy, and I liked that he communicated with me. 'I am not a psychoanalyst so I will discuss things with you, and make you feel heard,' he said. I felt safe and suddenly less alone, and I knew that this was the positive step I needed to make to start actually moving towards healing. It was time to start unpacking everything. Everything I've written on the pages of this book. Unpack it all, understand it better, and begin to heal from it. This was a first step in moving forward. We agreed to meet every Wednesday. I left the office that morning, walked back out onto the street, and as if it were some sort of romantic metaphor the fog had cleared. I knew this would be a long, and probably painful process, but I'd at least got the wheels in motion to start healing from all my pain. I began my walk home, feeling slightly lighter in each step. 'Hi, excuse me, do you have the time?' A lady approaches me to ask. I look to my watch, then look at my phone, and then back to my watch. 'It's 9:59,' I say, smiling. She giggles. 'Thank you.' I guess some parts of me I'm happy to keep just as they are.

EPILOGUE

In 2022, I was diagnosed as autistic. Many parts of this book were written before I made this discovery about myself, and going back through the stories after receiving my diagnosis was particularly interesting for me. I can see puzzle pieces littered throughout many of the events I talk about throughout my life, which all now form a clearer picture as to why I was expressing those behaviours and characteristics. I guess I've always felt different, or unique. I never put that down to anything other than just having slightly odd personality quirks, and an unusual approach to life. I thought a lot of it was due to my upbringing. For instance, being thrust into professional work environments that were more mature than might have been appropriate for my age at the time. I was pretty much a social outcast my entire school life, only clinging onto one friend here and there. Large groups were (and still are) difficult for me to navigate, and I often found myself sitting on the periphery looking in, analysing behaviours and wondering why people did certain things, behaved in certain ways, and would often feel quite content in many ways that I wasn't involved. I was often described as painfully shy, which was bizarre being a child actor, but it worked in my favour as adults found it incredibly endearing, and I still always professionally delivered on a job. Acting and performing for me in many ways was my escape. I wasn't really acting, I was elsewhere. When I was in a musical, nightly, in period costume, with

a live orchestra, I was in a different time and place. I didn't really 'get into character'—I just became them. I lived two different lives. One real, and one not. The entire experience was beyond the average person's comprehension, which is why my sense of self and identity has been so muddled and confused for so long. A lot of my differences I put down to that. When I went into adulthood, this endearing shyness, almost child-like behaviour, was no longer endearing; it was socially awkward, made other adults uncomfortable, and didn't translate into anything redeemable whatsoever. I found myself totally lost. I had no clue who I was or what I was doing as an adult in the real world. There were no other identities to escape into, and I was forced into living my own one, in a capitalist society where I had no other choice but to make ends meet. This was scary, and involved dissociating a lot. It was one in which I had unhealthy obsessions, would get stuck in loops, hyperfixate on projects, to only ditch them when I got bored. I would also hyperfixate on people and lovers, only to realise they weren't actually good for me. I would watch the same TV shows and films on a loop for over a decade, and only eat the same foods because they comforted me, no matter how unhealthy. Supermarkets would make me glaze over, and I'd go into a state of panic just walking through the aisles. My anxiety and depressive episodes were becoming far more frequent and more intense. I'd find myself screaming and pulling my own hair out, at the smallest inconvenience that the ordinary person would see as something that simply needed to be solved. I went through adulthood metaphorically flipping tables a lot, in work and schooling environments, and also in relationships, finding myself having a very short fuse if I was caught on a bad day and was dealt the wrong trigger. Friends would often tell me I was overthinking things a lot and causing myself unnecessary stress. I was pretty creatively talented, no matter

what I chose to do, I would be good at it, and wouldn't really stop until I felt I was accomplished. I've always loved reading, but would have to read the same page multiple times as my brain couldn't focus on the text. I was often misunderstood, judged as arrogant or rude by strangers who would meet me. I would drink alcohol in excess to attend any event where there were a lot of people, so I could be a more relaxed version of myself, one where I could get into character as someone more bubbly and outgoing. I would sit at dinners and others at the table would ask if I was ok because I seemed quiet. My planning skills became almost impossible and I would piss off relatives and partners because trying to plan something more than a week in advance used almost all of my brain power. Sending me wedding invites with a strict RSVP a year in advance was almost pointless. When I went into my early thirties I started discovering stuff online that discussed the many symptoms of different mental health conditions. I was curious as to why I was the way I was. I never really related to any of them specifically as such, until I started coming across a few videos by autistic creators, talking about the signs of autism. Over the next few months I went on a course of self-discovery. I researched a lot more about autism, and started making a list of signs that I felt I could connect with. Once I learnt more about the spectrum, I started going back over my life and making notes about all the things I felt were relevant. For note I have put them below:

Difficulty socialising in any/all groups.

Having burnout after long periods of forced socialisation.

Extreme general anxiety and bouts of depression.

Nervous breakdowns over certain stresses/triggers.

Hypermobility spectrum disorder - 7/9 joint hypermobility

Repeated behaviours:

Eat the same food for comfort daily/weekly.

Watch the same TV shows and films on a loop.

Go to the same places daily for comfort.

Spend a lot of time alone.

Not being able to hear/understand people in loud places.

Vividly frightening imagination and 7 years of night terrors as a child.

Have always sat weirdly, and in odd positions, sit with feet curled under on floor at almost all times.

Would prefer to socialise with adults over other children when I was a child.

Elements of being non-verbal, with asking my sister to ask/talk on behalf of me to parents, and friends/parents to talk on behalf of me in other social settings.

Have often been perceived as rude / aloof.

Hate loud noises / bangs / clanging. Particularly motorbikes.
Hate heavy breathing noises, whistling, and second hand noise.

Played a lot of pretend games and with barbies until about 14 years old.

Not many friends at school.

Anally retentive as a child.

Problems with eating at school/in public - would eat in private or out of my bag.

Dropped out of college.

Hyper sensitive to all smells.

Terrible motion sickness - boat/car. Smells of a car make me sick.

Don't like rollercoasters of any kind.

Hyper sensitive to the cold.

Issues with all physical affection from both friends, family and lovers.

Noticing details in stories/situations that others do not.

Become hyperfixated over one thing for a period of time.

Not knowing what friends/family are up to in their lives, not retaining

the information if they tell me.

Can't multitask successfully, will start one thing then move onto another and forget what I started first.

Inability to hold down a real job for extended period of time.

Work totally independently as a one man production and business.

Periods of hyper productivity then burnout.

People find me 'hard to read' or 'can't work me out'.

Preference for anonymous sexual habits.

Fear of dogs as child.

Corrective shoes when learning to walk as a toddler.

The final catalyst to me seeking a diagnosis was finding out that there is a link between autism and hypermobility joint syndrome. I was diagnosed with this in my twenties, when I had difficulties with my back while still working as a professional dancer. I'd always known I was 'double jointed' but it was more of a party trick than anything serious, and would usually involve me sitting in a box split at family parties as a kid, or bending my fingers back to touch my forearm, or later on in life having elastic legs in ballet or jazz, which gave me incredible facility as a dancer. Obviously, there are also many downsides to this syndrome which I'm only really learning more about recently, including a strong

link between hypermobility and mental health issues. After I learned about this link, I decided to book an autism assessment and confided in a couple of old friends. Upon telling my friends they validated my thoughts, and one friend even mentioned that he had suspected I might be for many years. This was a relief of sorts. I wasn't sure what I thought of this new discovery, let alone what my friends might think, so to have my thoughts validated by their suspicions, was somewhat satisfying. The idea of then moving forward with an official diagnosis, to give me some peace and understanding, and to share this information with others so they could understand me better moving forward in my life, was a very exciting prospect. So I took all this new information to a private ASD (autism spectrum disorder) specialist, and it was in this assessment, after a few questions and going through the extensive list I had compiled, that she diagnosed me with ASD1. She mentioned I would've been previously diagnosed with Asperger's, though it is now retired as an official medical term. The doctor discussed the different elements of the spectrum and how certain ADHD and autistic characteristics would be playing out in my life. The first thing I felt upon hearing this was relief. I felt like for the first time I was able to look back over my shoulder at over thirty years of life with a new sense of clarity. I had multiple a-ha moments. All the puzzle pieces fell into place and I could finally start to make sense of who I was. It felt like a new chapter, learning in real time why I was doing certain things, why I was feeling particular ways, and expressing unusual behaviours. The specialist who diagnosed me said 'now it's time for some self compassion.' I felt that a lot. I really needed to forgive myself. I carry a lot of guilt for some of my behaviours. A lot of shame. Times where I'd burnt bridges because I just couldn't cope, and I didn't understand why I was being such a brat. 'Histrionic' was a word that was once used against me at dance school.

The 'histrionic' behaviour I was expressing, they said, would never be tolerated in any industry I wanted to pursue a career in, and because of that they didn't see any future for me. It hurt so badly. I couldn't understand, and it felt like an injustice. I felt failed. My only regret with this new diagnosis is that I just wish I'd known sooner. I think maybe I would've been treated with more compassion at times. I sat down with my dad a few weeks after my diagnosis, I talked, and he listened, and then he joked 'you probably got that from me'. I jested 'I mean... you're very socially awkward'. Hereditary factors are quite important in ASD diagnoses, and there is an extensive mental health history on both sides. My grandmother was institutionalised whilst pregnant with my mother, and my grandad (my dad's dad), was also institutionalised. The likelihood I was on the spectrum was much higher given this family background. After letting my close friends and family know, letting them digest it, and after allowing them to ask me any questions they might have, I decided to let the world know on my social media. I thought it would give me some peace. I almost wanted it out there as a disclaimer of sorts, so that if people were to meet me they'd understand why I might present differently in social circumstances. After speaking about my diagnosis online many people were very sweet. I don't intend to be a role model or a spokesperson as such, I'm late-diagnosed so I'm still learning all about it myself, but if speaking openly about it makes others feel validated, seen, or inspired, then that can only be a good thing. So here I go into a new chapter of my life, with the knowledge of being actually autistic, actually neurodivergent, and actually Sam.

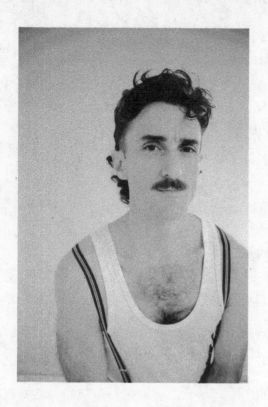

Sam Morris, a multidisciplinary artist from London, embarked on a remarkable journey that began with an illustrious career as a child actor. Unforeseen by many, Morris took a daring leap into the realm of adult artistry, unveiling his eponymous erotic platform in 2016. It was on this platform that his softcore boudoir photography emerged as a beacon of queer romanticism, captivating audiences and earning him widespread acclaim, including capturing the attention of international publications and esteemed fashion houses. In the year 2020, Morris unveiled a new facet of his creative expression with the release of his debut book, "Don't Fall In Love, Sam." This literary compilation features a poignant collection of essays and poetry inspired by his time dwelling in the hedonistic city of Berlin. Notably, Russell T Davies described the work as "like love letters from the edge," cementing Morris' place as a captivating storyteller. Presently calling Brighton, UK, home, Morris continues to channel his artistic energy into writing and creating. His evolving body of work reflects not only a multifaceted talent but also a deep connection to the nuances of human experience, establishing him as an influential figure in the contemporary artistic landscape.